Israel, Palestine
and Peace

AMOS OZ

Israel, Palestine and Peace

ESSAYS

A HARVEST ORIGINAL

HARCOURT BRACE & COMPANY

San Diego New York London

Requests for permission to make copies of any
part of the work should be mailed to: Permissions Department,
Harcourt Brace & Company, 6277 Sea Harbor Drive,
Orlando, Florida 32887-6777.

Library of Congress Cataloging-in-Publication Data
Oz, Amos.
[Essays. English. Selections]
Israel, Palestine, and peace: essays/Amos Oz.
p. cm.
"A Harvest original."
Previously published: Whose Holy Land?
New York: Vintage, 1994.
ISBN 0-15-600192-6
1. Jewish-Arab relations—1973–ㅤ2. Israel—Politics
and government. 3. Palestine—Politics and government—1948–
I. Title.
DS119.7.O96ㅤ1995
956.9405—dc20ㅤ95-5777

Designed by Lori J. McThomas
Printed in the United States of America
First edition
A B C D E

Acknowledgements

'Integrity'
Speech, Budapest, October 1985. Translated by Amos Oz
and Maggie Goldberg-Bartura.

'Has Israel Altered its Visions?'
New York Times Magazine, 11 July 1982. Translated by
Maggie Goldberg-Bartura and Amos Oz.

'The Real Cause of my Grandmother's Death'
Lecture, Tel Aviv, 1992; Cambridge 1993. Translated by
Ora Cummings.

'From Jerusalem to Cairo: Escaping from the Shadow of the
 Past'
Encounter, 1982. Translated by Nicholas de Lange.

'Between Europe and the Negev Desert'
Interview, *Frankfurter Allgemeine Zeitung*, 3 May 1990.
Translated by Jenny Chapman.

'Peace and Love and Compromise'
Acceptance Speech, International Peace Prize of the German
Publishers' Association, Frankfurt, October 1992.

'Whose Holy Land? Divided Israel in Palestine'
Weekend Guardian, 23–24 December 1989. Translated by
Nicholas de Lange.

'Telling Stories under Siege'
Speech, Writers' Conference, Barcelona 1976. Translated by
Maggie Goldberg-Bartura.

'The Israeli-Palestinian Conflict: Tragedy, Comedy and Cognitive Block'
Lecture, Ann Arbor, 1992.

'At the Bridge'
Guardian, 1 September 1993. Translated by Ora Cummings.

'Hizbollah in a Skullcap'
Observer, 27 February 1994. Translated by Ora Cummings.

'Clearing the Minefields of the Heart'
Speech, Peace Now rally, Tel Aviv, 4 September 1993. Translated by Ora Cummings.

Contents

Preface

THIS COLLECTION CONTAINS essays, articles, speeches and one interview, written or delivered over a period of several stormy years. Many of them were born out of bewilderment, shame and rage; most of them were not written in cold blood. Re-reading these articles, I have omitted some repetitions – the usual crime and punishment of a long effort to convey an argument to reluctant audiences. However, some repetitions remain, serving perhaps as a persistent refrain.

Much of this book deals with the Israeli-Palestine conflict. As a storyteller, I find I can live, perhaps more easily than others, with the existence and validity of two mutually exclusive narratives concerning the causes and the consequences of this tragedy. Were it not soaked in death and suffering, I might even have found a certain comical dimension to the mirror image relationship between fanatics and self-righteous preachers on both sides. In my view, however, it is not necessary for Israelis and Palestinians to reconcile the contradictory versions of their past histories in order for them to live peacefully side by side in the future. There is no need to establish whose fault it was, whose blindness it was that caused the tragedy. What we need is to find a way out of the mire.

Israelis and Palestinians may disagree with each other forever over the narrative and significance of their interwoven histories. Nevertheless, they might benefit from injecting a measure of relativism into the usually rigid

conceptions of the normality of each other's past and present positions.

Since 1967, a number of Israelis have been advocating a two-state solution, based on the partition of the land, roughly according to demographic lines. This idea has, for many years, been a hard one to sell, both to the Israelis and to the Arabs: most Israelis felt that the war we fought in 1967 was a just war of self-defence, that ancestral land acquired in that war ought not to be returned to the Arabs, who would settle for nothing short of the extermination of Israel. The Arabs, for their part, including the Palestinians, were claiming – until a few years ago – that the creation and the very existence of the State of Israel is, in itself, an act of aggression against them, and that therefore Israel ought not only to be kicked out of the territories she conquered in 1967 – she must be made to go away altogether.

Most people on both sides could make no moral distinction between the right over the West Bank and the right over Galilee.

The idea of a territorial compromise based on mutual recognition was able to gain ground only after both sides found themselves on the receiving end of a few painful slaps of harsh reality: the Arab defeat in 1967, the Israeli near-defeat in 1973, the bilateral Israeli-Egyptian peace-for-land treaty in 1978, the Lebanon fiasco in 1983, the Palestinian *intifada* uprising since 1987, the Gulf War in 1991, the change of government in Israel in 1992, the Oslo accords in 1993 and, recently, the implementation in Gaza and Jericho of the initial phase of the first agreement ever signed by Israelis and Palestinians. Each one of these events should be viewed as a stepping-stone on the long road to a tormenting, cognitive change on both sides; each of them prompted the realization that merely ignoring the existence or aspirations of the Other, would never make that Other go away.

As I write this preface (in July 1994), nearly half of the Palestinians who lived under Israeli military administration between June 1967 and May 1994, the inhabitants of the

Gaza region and of Jericho district, are enjoying a PLO
regime. A PLO police force and Israeli troops are conducting
joint patrols along the new lines, providing relative calm
for both sides. A modest measure of co-ordination and even
co-operation is beginning to develop between the former
deadly enemies. The Palestinians do not yet enjoy full sover-
eignty anywhere, nor have they had the chance to elect their
own government. But if the present phase of the agreement
is carried out with sincerity and wisdom by both sides,
'Gaza and Jericho first' can evolve in a few years into a
Palestinian state comprising most of the territories occupied
by Israel in 1967.

For a very long time Arabs, Israelis and outside observers
mistook this conflict for an ethnic clash between two com-
munities within one society; or for a religious war; or for a
struggle for de-colonization; in short, for some kind of civil
war. At last, both parties are beginning to see it for what it
is – an international conflict, a clash between two different
nations each claiming the same piece of land for itself. In a
word, a dispute over real estate, albeit steeped in historic
traumas and wounded feelings on both sides.

A dispute over real estate can be resolved through a
compromise which may leave no one happy, but enables
everyone to stop killing and being killed. I have maintained
since 1967 that 'wherever right clashes with right, a value
higher than right ought to prevail – and this value is life
itself'.

A great deal has yet to be negotiated between the parties:
security, boundaries, Jerusalem, settlements, water, economic
relations, and comprehensive regional peace accords, to
mention only the main issues. But the departure point for
the hard work is now accepted by the main parties: we have
agreed that the matter of Israel and Palestine is no longer
an 'either-or' issue; that the two national aspirations are not
condemned to be mutually exclusive.

While dealing with the Israeli-Palestinian tragedy, this
book is also about the moral dilemma of a writer during

troubled times and in a conflict-stricken place. How involved can a writer become without sacrificing his art? Or can he remain detached without losing human decency?

Some of the essays in this book deal with the corrupting impact of prolonged struggles, even when these struggles are for a just cause. Winston Churchill might have been right or wrong in thinking that the Battle of Britain gave his people 'their finest hour'. But the Battle of Britain was a relatively short one. A conflict which spans several decades is bound to deteriorate into a cycle of blows and counter-blows, of mistrust and vindictiveness, with degrading consequences for almost everyone involved.

These essays are not the result of 'post-Zionist' guilt or feelings of remorse towards the Palestinian people. I still maintain that Israel is the only homeland of the Israelis and that, in the future, Israel should be prepared to take in Jews who may wish to become Israelis and Jews who might be forced by anti-Semitic hostility to migrate to Israel. At the same time, I regard Palestine as the legitimate and rightful homeland of the Palestinians. As it seems that Israelis and Palestinians cannot share their homeland, it must be divided between them.

Ultimately, these pages were written by an Israeli who fought for his country and who loves it, even during dark times when he was unable to like it. I have never maintained that 'right or wrong – I must stand up for my country'; I have often felt that my country will survive and prosper only if it does right.

Arad, July 1994

Israel, Palestine and Peace

Integrity

THERE IS NO Hebrew word for integrity: perhaps we Jews lack this 'Roman' quality altogether. In my dictionary I found, among other synonyms for integrity, 'intactness, wholeness, being firm, in one piece'. We Jews are probably made of several pieces, not of one.

Can we really expect a poet or a storyteller to be 'whole' or 'intact' in any sense? Can the inventor of plots and characters, the creator of a substitute reality, be 'firm, in one piece'? Isn't he or she forever in the business of dismantling and reassembling? Isn't the poet or the writer dealing with mosaic rather than with a block of marble? Fascinated by the differential rather than the integral of things? Indeed, D. H. Lawrence carried this premiss one step further when he said that a storyteller must be capable of presenting several conflicting and contradictory points of view with an equal degree of conviction.

Poets and storytellers are sometimes regarded as witnesses. One tends to expect a certain integrity from a witness, at least integrity in the sense of honesty, sincerity and objectivity. Yet, while writers usually testify for the prosecution, they are also witnesses for the defence. Worse still, the writer or poet is a member of the jury. But isn't he also the interrogator who has exposed, unmasked the accused? And isn't he or she at the same time a relative of the accused? And the family of the victim, too? He or she may act as the judge as well. He may secretly plot an escape

1

while arming the jailer. Can such a dubious character have any integrity at all?

But let's consider the role of the writer as a defender of the language, the one who can read the warning signs and sound the warning bells.

Tyranny, oppression, moral degeneration, persecution and mass killing have always and everywhere started with the pollution of the language, with making what is base and violent sound clean and decent ('the new order', 'final solution', 'temporary measures', 'limited restrictions'), or else with using coarse and bestial language where it should have been humane and delicate ('parasites', 'social insects', 'political cancer' etc.). The writer ought to recognize that wherever a human being is referred to as a parasite or a germ, there will follow, sooner or later, death squads and exterminations. Wherever war is called peace, where oppression and persecution are referred to as security, and assassination is called liberation, the defilement of the language precedes and prepares for the defilement of life and dignity. In the end, the state, the regime, the class or the idea remain intact where human life is shattered. Integrity prevails over the fields of scattered bodies.

My own excursions into political essays started with a 'linguistic reservation'. In 1967, immediately after the Six Day War (which I regarded as a justifiable battle for Israel's self-defence), I wrote an article deprecating the use of the term 'liberated territories'. I insisted that territories simply cannot be liberated, that the term 'liberation' can only refer to people, not to valleys and mountains. Fifteen years later, writing about the Israeli invasion of Lebanon in 1982 (to which I fiercely objected) I wrote an essay stating my bewilderment at the official Israeli title for that bloody war: 'Operation Peace for Galilee'. A war, I argued, even the most justifiable one, cannot be called peace.

Back to our dubious character whose integrity begins and ends within the domain of words: he can use his words for building castles, for playing brilliant games, for calling death

a rose. But he is also capable, and therefore responsible, for calling a rose a rose, and a lie a lie, for calling villainy villainy, and torture torture. His way of sounding the alarm makes him the horror of tyrants. Isn't every censorship in the world an indirect manifestation of awe for the power of the writer's words? We are talking about tyrants who usually have their lunatic integrity but who are terrified of those wordy characters who lack integrity. They are afraid of the writer because he knows them intimately, he knows them through and through – he has journeyed through their minds. Nothing is alien to this dubious character. Every madness, savagery, obscenity and ruthlessness in the mind of the tyrant must have crossed the poet's mind as well.

I doubt if any writers and poets have integrity or even should have. I believe, though, that some of us are capable of defusing the deadly integrity of the fanatic, the mono-maniac, the raging ideologist, the murderous crusader. I think fanaticism is *their* department, whereas comparative fanaticism is ours. Let them dwell in their marble mauso-leums – we dwell in our patient and precise mosaics.

<div align="right">

Speech, Budapest, October 1985
(Translated by Amos Oz and Maggie Goldberg-Bartura)

</div>

Has Israel Altered its Visions?

ON THE NINTH day of Israel's invasion of Lebanon, the Israeli Peace Now (Shalom Achshav) movement placed the following advertisement in the newspapers:

'In this war, the Israeli Army is proving once again that Israel is powerful and self-confident. In this war, we are losing brothers, sons and friends. In this war, thousands are being uprooted from their homes, and towns are being destroyed. Thousands of civilians are getting killed.

'What are we getting killed for? What are we killing for? Has there been a national consensus for going into this war? Has there been an immediate threat to Israel's existence? Will it get us out of the cycle of violence, suffering and hatred?

'We call upon the Government of Israel: Stop! Now is the time to invite the Palestinian people to join in negotiations for peace. Now is the time for a comprehensive peace based on mutual recognition.'

It was a courageous plea to make in the middle of bitter fighting against a deadly enemy. Some Americans, remembering their anti-Vietnam War campaign, might consider the appeal too mild, for it stops short of calling for an unconditional Israeli withdrawal. But that only reflects the difference between the American anti-war phenomenon and the Peace Now movement, which was founded by a group of army reserve officers immediately after President Anwar el-Sadat's 1977 trip to Jerusalem and which quickly gained ground among the better-educated young.

The American doves had maintained that the United States was involved in the wrong war against the wrong enemy for the wrong reasons and should pull out of Vietnam immediately and at any cost. The Israeli doves are not pacifist by any means. Israel's enemy is real and uncompromising; essentially, until the war in Lebanon, the country has been fighting for survival and security. Few if any Israelis believe in unconditional, unilateral withdrawal from the West Bank and Gaza. Not a single member of Peace Now disobeyed the mobilization orders that accompanied the drive into Lebanon. Many of the reserve officers who belong to the movement have been serving on the battlefield. Some of them have died in the fighting.

Nevertheless, there is an argument in Israel between, on the one hand, Peace Now and some elements of the Labour Party opposition and, on the other hand, the Begin Government and its supporters. The dispute has deep roots in the history of modern Zionism. Hawks and doves are divided over much more than boundaries and territories. They disagree about the very purpose and character of the Jewish state.

Moreover, they are divided over the philosophical significance of Jewish history. Whereas the hawks are convinced that the Jews are liable to some mysterious primeval curse, bound to remain forever isolated, hated and persecuted regardless of the way they act, the doves maintain that there is no such mystical verdict and that there is a correlation between Israel's actions and Arab and world response.

The hawkish conclusion is rough and simple: if the 'nice Jewish boy' is the eternal scapegoat, let us Israelis turn ourselves into a terrible Jewish roughneck who will evoke at least fear, and maybe even some respect. The doveish position, on the other hand, is much more complex, ambivalent and difficult to explain. To understand it, we must go all the way back to the roots of the humanitarian socialist movement that fashioned the foundations of modern Israel

out of the ancient dream of a return to our ancestral homeland.

Israeli socialism was born some 80 years ago of an uneasy marriage between two different traditions – the Jewish tradition of social justice and the Eastern European, and particularly Russian, social visions of the time.

Let me dwell first on the Jewish genes. Within Judaism, there has always been a powerful conviction that all men are created equal before God; a sudden touch of divine light can turn a peasant into a prophet, a shepherd into a king of Israel, a simpleton into a *tsadik nistar* (one of 36 unknown men of virtue who, by their presence in each generation, save mankind from divine wrath). Indeed, the prophecies of Amos and Micah have as much, if not more, socialist and even anarchist fire than any modern revolutionary manifesto.

Through centuries of scattered existence in several diasporas, Jewish communities everywhere developed highly advanced and sometimes highly sophisticated voluntary systems of social welfare, dealing not only with material needs but with communal activity designed to drive away loneliness, alienation and mental suffering. Despite extreme poverty, diaspora Jewish communities did not let an individual die of starvation or remain illiterate; a net of voluntary taxation was stretched out to support the poor, the aged and the crippled. Education was regarded on religious grounds as a basic human right and a prime social duty. I cannot think of any nation-states, except for a very few in the twentieth century, whose laws attained to the same degree of social progressiveness. Incidentally, one of the social duties assumed by traditional Jewish communities was never to leave a young woman without a bridegroom or a young man without a bride, which is more than any contemporary socialism can claim for itself.

So much for the Jewish genes in Israeli socialism. Turning now to the Russian ones, we should focus not on the social

theorists, like Aleksandr Herzen and Mikhail Bakunin, but on the great nineteenth-century Russian writers. It is ironic, of course, that an observer of the decadent Russian aristocracy like Ivan Turgenev, or a populist mystic like Leo Tolstoy, or a reactionary Christian-Slavophile romantic like Fyodor Dostoevsky, should have stirred a socialist vision in the early Zionist pioneers, but that's how it was.

The small-town Jewish idealists who were influenced by these giants could hardly tell the difference between liberalism and radicalism; both were perceived as redeeming alternatives to the misery, puritanism and religious oppressiveness of traditional Jewish life. Jewish youths sick and tired of the stifling atmosphere of the Jewish petite-bourgeoisie of Eastern Europe embraced Tolstoy's prescription of going back to the land, mingling with the peasants, enlightening them and being healed by the pure simplicity of rural life. They adopted Dostoevsky's Christian ideal of self-dedication to the point of self-negation as an answer to the aimlessness of their own lives.

All this the early settlers brought with them to Palestine shortly after the turn of the century. Sadly enough, they couldn't wrap the Arab peasantry in Tolstoyan lovingkindness because of the language barrier and other reasons. So they assumed the double role of peasant and populist: while toiling on the land, in terrible suffering and hardship, they 'educated' themselves, 'enlightened' themselves and 'healed' themselves. Galilee must have been a very peculiar stage for many dramatic Dostoevskyan scenes of soul-searching far into the night. Those early Zionist Socialists were simultaneously drying the swamps and arguing about the social, political, ethical and theological significance of each of their actions. As a result, I believe nobody ever slept in Palestine during the first twenty years of this century.

It would take a trilogy to describe the mosaic of ideological, political and philosophical groups among those enthusiastic pioneers. There were anarchists and mystics, Plekhanovites and Kropotkinites, Narodniks and altruists,

and, later on, Marxists, Trotskyists and even some Stalinists. In those early years, I dare say, there were probably more political groups than individuals, since each of these peasants-cum-theoreticians had a divided mind and soul.

But there was absolutely nothing to revolutionize in the Jewish sections of Palestine in those years, neither industry nor agriculture, neither big cities nor real villages. Consequently, these world reformers were reduced to attacking their own souls, attacking one another and attacking the harsh land itself. In this they were inventive. They established various forms of communes, 'work brigades', cultural committees, and so on. The slogan was, 'We came to this country to build it and to be rebuilt by it.' They put strong emphasis on the need to change human nature, to revolutionize the 'Jewish psyche', to heal their own tormented souls.

Strangely enough, one can say in retrospect that they were very practical. They experimented with various types of agricultural co-operation, quickly abandoning any scheme that didn't work. Poverty and harsh living conditions taught them how to farm and how to manufacture. Endless debates and arguments taught them how to strike an uneasy ideological consensus.

They were all sorts of things, but they were not lunatics. They were full of zeal, but removed from fanaticism. The world is full of dogmatic movements pretending to be pragmatic; observing these founders of kibbutzim in Israel, I tend to believe that they have been a pragmatic lot pretending, because of some emotional urge, to be dogmatic. They always had their principles, convictions, complicated theories, but these were moderated by an enormous respect for realities.

Let us now consider some of the major trends during the epic years of Zionist socialism – the years preceding the creation of the state of Israel – as personified by some outstanding characters.

Aharon David Gordon (1845–1922) was 48 when he left his small town in Russia to become a farmhand in Palestine in 1904. He was a Tolstoyan who believed in peoples but not in nations, and especially not in nation-states. His key notion was self-healing through hard physical labour. In sharp contrast to Karl Marx's concepts, Gordon believed that everything begins with the uniqueness of each individual, that society is a complex of differing individualists and that spontaneous religious experience is the answer to the ritualistic and oppressive – and hence 'inhuman' – character of all institutionalized religions. His vision was a Palestine turned into a loose federation of small, self-contained rural communities, wherein individuals were likely to achieve religious self-purification through constant contact with nature. His followers were later to comprise the most anti-chauvinist, anti-bureaucratic and anti-Marxist faction of the broad political and cultural coalition that formed the Israeli Labour movement.

Yosef Chaim Brenner (1881–1921) was one of the greatest figures of modern Hebrew literature. A former rabbinical student and a Russian world reformer, Brenner seemed to have stepped right out of a Dostoevsky novel. In his stories, novels and essays, he was an existentialist long before existentialism, a pessimist, a sceptical social thinker disillusioned by all social institutions of any sort or form, doubtful about the prospects of Zionism itself. He believed that it is only through struggle against the devil in one's own soul that the human condition can be slightly improved. He also believed in the healing powers of hard physical work and total silence (although he personally failed at both). It may be ironic to point out that Brenner is regarded as the spiritual father of both of the two conflicting attitudes towards the Arabs that contend within the contemporary Israeli Labour movement – the hard-line, essentially pessimistic approach of 'establishing facts by building more settlements and struggling against odds', and a realistic, moderate approach ready for compromise with the Palestinians.

Berl Katznelson (1887–1944), a self-educated intellectual from a small town in Russia, a teacher, worker, political organizer and theorist, rose gradually to the status of a secular 'rabbi' for most of the early pioneers. A man who seemed unable to hold onto any official position, regular job or even permanent home, he none the less became a great unifier who synthesized the various splinter groups and personally laid the foundations for half a dozen organizations, such as the Union of Agricultural Workers, the Union of Cooperatives and Kibbutzim, the national health-care system, the workers' central bank, the Labour movement's daily newspaper and its publishing house and, finally, the Histadrut – the shadow government of the shadow state that the Jewish community created in the days of the British mandate in Palestine.

Whereas Katznelson became the rabbi, David Ben-Gurion (1886–1973) created and gathered the power, first within the Labour movement, then within the Jewish community in Palestine, then over the majority in the world Zionist movement, and finally as the almost omnipotent first Prime Minister of the state of Israel. Ben-Gurion was a lifelong disciple of Katznelson but worlds apart from him in his political talents and his tactical shrewdness. He had deep respect for theories and visions but equally deep faith in organization and power structures. Together with others, he formed the underground embryo of the Israeli Army. Influenced by the Bolshevik October Revolution, deeply, if secretly, inspired by Lenin's personality, Ben-Gurion was, at the same time, a man who had spent some of his formative years in America and never lost his democratic convictions and his admiration for the West.

In retrospect, one cannot avoid the conclusion that the greatest asset of Israeli socialism was that it started from scratch. Unlike any other socialist movement in the world, the early socialist Zionists had nothing to reform, seize or conquer. They had a clean page before them, and so they created industries, settlements and social and cultural insti-

10

tutions on a uniquely egalitarian basis. The farms belonged to the settlers, the factories to the workers, the publishing houses to the readers, the socialist bank to its customers. They developed a method of government and management through argument and persuasion.

The only sanction the leaders could exercise was the pressure of public opinion. They were not in a position to impose penalties or to promise rewards. In fact, the civil servants of this shadow government were paid their salaries according to the size of their families and not according to their rank in the hierarchy. For many years, the Secretary-General of the Histadrut received a considerably smaller salary than the cleaning woman in his office building, who had six children. The underground army, the Haganah, operated more like a youth movement than a conventional military force, relying on persuasion, voting and consensus rather than on orders.

So as not to arrive at too idyllic a view of pre-independence Israeli society, one should bear in mind some of the quasi-Bolshevik methods used by the leadership to manipulate public opinion. It should also be noted that a ruthless struggle went on throughout the 1920s, 1930s and 1940s between the Labour movement and its right-wing, chauvinistic, religious and conservative opponents within the Jewish community in Palestine. The conflict was over concepts and tactics relating to economic policy, the struggle against the British and the defence of the Jewish community against violent Arab attacks. It pitted Labour both against extremist militant organizations such as the Irgun, led by Menachem Begin, and the early manifestations of 'pocket capitalism' that crept in with the subsequent arrival of anti-socialist Jewish immigrants.

None the less, despite these divisions, the Jews of Palestine maintained a fundamental accord personified by a collective leadership of dreamers, poets and world reformers of all kinds. In many ways, Israel was on its way to becoming a twentieth-century version of an Aristotelian Greek *polis*,

characterized by the highest degree of individual involvement in public affairs. Hence, in 1947–8, when the British mandate was about to expire and the War of Independence broke out, the Jews were ready not only for the military test against the armies of seven Arab states but for the demands of statehood.

Kibbutzim, trade unions, a financial infrastructure, superb combat forces, highly advanced medical services, a network of educational institutions – almost everything needed for a modern, progressive and sophisticated state emerged as a system of state institutions. Even the agrarian structure was right, ready to absorb hundreds of thousands of new immigrants: a doubling of the country's population within three years of independence. To this day, only about 5 per cent of the land is privately owned; the rest is public property, in one way or another.

In short, Israel could have become an exemplary state, an open, argumentative, involved society of unique moral standards and future-oriented outlook, a small-scale laboratory for democratic socialism – or, as the old-timers liked to put it, 'a light unto the nations'. But at that point, when everything seemed ready for such an emergence, crisis set in.

Why didn't Israel develop as the most egalitarian and creative social democratic society in the world? I would say that one of the major factors was the mass immigration of Holocaust survivors, Middle Eastern Jews and non-socialist and even anti-socialist Zionists who ached for 'normalization'. The Holocaust convinced many Jews that the cruel game of nations had to be played according to its cruel laws: statehood, a military establishment and a pessimistic concept of the use of military power. At the same time, some of them wanted Israel to become a replica of pre-war, bourgeois Central Europe, with red-tiled roofs and good manners, 'Frau Direktor' and 'Herr Doktor', gemütlichkeit and Bavarian cream – a transplant of Franz Josef's Vienna onto the soil of the Holy Land. For them, socialism meant anar-

chy, a threat to private life and freedom. Indeed, to many of them, socialism simply meant Stalin.

Then there were the masses of Orthodox Jews who wanted to create a replica of a Jewish ghetto and to whom socialism meant blasphemy and atheism. As for the North African Jews, and many of the Central Europeans, they brought with them the attitudes of a French-inspired middle class – conservative, puritan, observant, extremely hierarchical and family oriented, and, to some extent, chauvinistic, militaristic and xenophobic. These arrivals, together with many of the Polish and Romanian immigrants, wanted Israel to become a 'decent' little nineteenth-century France.

For all these hundreds of thousands of Jews who came to Israel in the 1950s, the spectacle of a Prime Minister wearing khaki shorts and an open shirt was an abomination. They wanted to 'sir' their superiors and give orders to their inferiors. They wanted bourgeois cosiness and stability. They hated those 'socialist lunatics' who sent them to become peasants and factory workers, patronizing and oppressing them with their melting-pot mentality and their contempt for the new immigrants' 'backward', 'primitive' and 'reactionary' traditions.

The new arrivals could cope with having to be poor for a while, but they hated the very idea of the President of Israel residing in a block of flats, as President Itzhak Ben-Zvi initially did, or spelling the police constable for a couple of hours in the sentry box in front of the Presidential residence, as Ben-Zvi did after the residence was built. Prime Minister Ben-Gurion's insistence on calling himself an 'agricultural worker', even on his identity card, was received by these people almost as a personal insult. They wanted the country to be run by a respectable gentleman dressed in a proper suit, kissing ladies' hands and going to synagogue (or at least using religious vocabulary), a leadership personifying the fact that we Jews were no longer pedlars, fiddlers, a ragtag lot, but a 'decent' nation like all others. In short, they wanted Begin, and they finally got him.

Paradoxically, the socialist founding fathers had had to suppress similar impulses within themselves. For decades, in their heart of hearts, they stifled their own middle-class, conservative, Orthodox upbringing. And so, slowly but steadily, a constant demand for 'normalization' created a supply of its trappings. The leaders, some more than others, gradually adjusted to the conventional role of conventional government ministers, members of parliament, ambassadors, managers, and so on. The veteran leadership gradually lost its romantic zeal and became a powerful oligarchy.

Ben-Gurion expressed this shift of hearts and minds in the virtually untranslatable Hebrew word *mamlachtiut*, which could be rendered in English as statism, although Ben-Gurion would have rejected the dehumanizing connotations of that term. He simply felt that Israel needed a regular army and a government that would govern rather than preach; that education, housing, medical care, and so on, should no longer be the business of fussy ideologists; that the embryonic socialist community should be institutionalized. This shifting of gears was challenged by some of Ben-Gurion's rivals among the veteran socialists, by some young Israeli-born intellectuals and by the kibbutz movement. Ben-Gurion thereupon formed a coalition government with the religious parties and, eventually, with the major right-wing conservative party.

For those holding on to the early faith, it was a struggle against impossible odds. Most of the new immigrants chose 'respectability' over egalitarianism. Stalinist Russia became Israel's deadly enemy, an ally of its Arab foes. Socialism became associated with the devil. Israel was gradually pushed, first by Soviet policies, then by the growing antagonism of the third world, into a strongly pro-Western foreign policy. More recently, the antipathy of the European New Left, which had a powerful effect on European policies towards Israel, contributed to Israel's sense of exclusion and helped push it into the arms of its most reactionary partners, such as South Africa and Argentina. It would be fair to say

that this New Left included intellectuals of the do-gooder type who had questioned Israel's very right to exist long before it occupied a single inch of its neighbours' territory.

It was in the early 1960s, during the Lavon Affair, that the ageing socialists were finally defeated. Pinhas Lavon, a disciple of A. D. Gordon and founder of a pioneering youth movement, was the victim of a political intrigue that sought to saddle him with the responsibility for certain adventurist Israeli intelligence operations in Egypt in 1954, when he was Defence Minister. Ben-Gurion's support of some of Lavon's enemies within the defence establishment led him to challenge the Prime Minister's philosophy and leadership; that made Lavon a rallying point for the old-time Labour leaders who opposed the Prime Minister's concepts of statehood. They lost, and the Lavon Affair marks their last battle and the rapid collapse of the Socialist-Zionist dream. Still, they were strong enough to take Ben-Gurion down with them; the Prime Minister was compelled to retire.

And so, by 1964, both Ben-Gurion and Lavon were gone. The fabric of the Histadrut, the kibbutz movement, the progressive welfare state and Labour's political hegemony were still in place, but unravelling. It all became less and less inventive drama and more and more an institutionalized museum. Levi Eshkol, a good-natured, pragmatic ironist, tried as Prime Minister to defend the initial dream, but despite his humanity and devotion, and the help he got from others, he was not the man to revive the old spirit or inspire idealism in the young. Israel had undergone the process of becoming a conventional welfare state, with a tendency towards Americanization.

The rest was caused by the savage Arab attempt to destroy Israel. The Six Day War of 1967 brought a double realization – of Israel's military strength and of its international isolation. The nation was swept into a mentality totally alien to the vision of the founders of Zionist socialism. The very language had changed. 'Russianness' and Hasidism, diaspora sensitivities and world-reforming dreams

15

gave way to biblical clichés, territorial ambitions and intoxication with the power of arms.

Golda Meir, with her typical attitudes of self-pity and self-righteousness, with her sardonic bitterness towards the 'outside world' and her simplistic patriotic slogans, was an authentic voice of this new national mood. Younger political and military idols – Moshe Dayan, Ariel Sharon, with their fundamental pessimism and ruthlessness and their cynical treatment of all ideals except heroic patriotism – became the symbols of Israel's image of itself.

Is there an alternative? Under the Begin Government, more and more young Israelis are coming to feel restless and unhappy about their perspectives in a small, militant nation-state armed to the teeth, attuned to vague biblical sentiments and committed to medieval religious fundamentalism. The stony philosophy of siege and retaliation tastes sour and bitter to many of Israel's sons and daughters. The reality of an Orthodox, nationalistic fortress has become the dialectical ground for creative discontent.

Young people, the vast majority of the intellectual community, the kibbutz movement and many of the artists and thinkers have rediscovered the secret charm of the original visions. There is a subterranean move towards far-reaching reassessment. The Peace Now movement, with its conviction that annexation of the Occupied Territories would be disastrous to Israel's social fabric, is only the tip of the iceberg. Ideas developed more than half a century ago by Gordon, Brenner, Katznelson and others are being re-examined and reinterpreted.

In my view, there is no going back to those Hasidic-Tolstoyan experiments of 60 and 70 years ago. There is hardly a chance for the re-emergence of ecstatic world reforming. There is no chance of survival for a pacifist Israel within a militant neo-fundamentalist Middle East. There are, none the less, some amazingly relevant elements of the initial elements of the initial dreams that can be reintepreted, extended and applied when Beginism reaches a dead end.

Israel is bound to suffer, sooner rather than later, the harsh slap of reality. The early socialist Zionists were right in assuming that freedom was indivisible, and that if Israel became an oppressive, colonial society, it was bound to lose its soul. That an overwhelming majority of Israelis responded to Sadat's peace initiative with a burst of emotion, changing their minds almost overnight and giving back to Egypt every grain of Sinai's sands, is spectacular proof of the secret vitality of the nation's original humanitarian and peace-loving spirit. I dare to predict that if a Palestinian leader were to follow Sadat's example, break the emotional barrier and offer Israel full-scale peace and security, many of the present hard-liners would present him with an olive branch.

The Israelis may have to dominate the West Bank for as long as the Palestinians refuse to recognize them and co-exist with them. Nevertheless, we must in the end come back to what has been socialist Zionism's standing offer to the Palestinian Arabs – reasonable partition of the country in accordance with demographic realities; recognition for recognition; security for security; self-determination for self-determination.

Even if the present Palestinian leadership – and, indeed, most of the Arab world – rejects this proposition, we need to make it and stick to it, in order to remain what we are, and in order to go on building the country and being rebuilt by it. Such a proposition, I believe, is also the precondition for making Israel attractive again to idealistic young Jews everywhere. Moreover, the dreamers were right in asserting from the start that statehood is a vehicle, not a goal in itself; that society can be creative, inventive and dynamic only when individuals do not feel anonymous; that the welfare state is not enough.

The various Zionist models of small social cells, where people live, work, argue, divide and create within perimeters of shame and perimeters of pride, may be an answer to the crisis of Western social democracy; ultimately, as A. D.

Gordon put it, the two deepest and most fulfilling human experiences are creation and responsibility. Any society, capitalist or centralized, bureaucratic or socialist, that denies individuals these two deepest human delights is bound to turn us into miserable cripples. For all its faults and setbacks, the kibbutz is still the single most fascinating enterprise in the opposite direction. Besieged by enemies, disillusioned with the vision of international solidarity, tormented by endless wars and partially corrupted by petit-bourgeois, chauvinist and certain kinds of religious attitudes, Israeli society still treasures a Sleeping Beauty.

Will the beauty wake? Will this restlessness lead to a renaissance of the Israeli Labour movement? The single most encouraging phenomenon in today's Israel is the re-emergence of dialogue between the soul-searching young and their own grandparents. There is no question, for the young, of going back to their roots or re-creating the days of old. There is no chance of a sentimental journey back to the euphoric early decades. But there is, at long last, despite the pathetic weakness of the Labour Party's present leadership, a painful reconsideration of the ideological, ethical and political propositions of the early Zionists, a growing tendency on the part of young Israelis to give a flat no to their parents – and, at the same time, to say 'perhaps' to their grandparents. The rest is yet to be seen.

New York Times Magazine, 11 July 1982
(Translated by Maggie Goldberg-Bartura and Amos Oz)

The Real Cause of
My Grandmother's Death

MY GRANDMOTHER DIED of cleanliness. She came to Jerusalem from Poland one blazing summer's day in 1933, cast one terrified glance at the markets, the alleyways, the inhabitants, and decreed: 'The Levant is full of microbes.' For the next 25 years, this would be her motto. I think it was on the next day that she first ordered my poor grandfather to do what she would be ordering him to do every morning for the rest of her life in Jerusalem: to get up at the crack of dawn, spray down the whole apartment with DDT and take the sheets, blankets – and mattresses – out to the balcony and beat the life out of them over the railings – these being, presumably, pre-emptive measures in her everlasting battle against germs. Throughout my childhood, I remember my grandfather, at the break of dawn, beating out his rage or frustration on those mattresses – and he would pound the dust out of them just as fervently as Don Quixote combated his windmills. This story, however, is not about my grandfather, but about my grandmother.

No fruit or vegetable would pass our lips before being mercilessly boiled – for the Levant was full of microbes. Even bread had to be wiped down with a cloth soaked in some pinkish chemical solution with a name something like 'Cali'. After meals, her dishes were not washed, they were boiled. In fact, she practically boiled herself too, in the three-times-a-day, summer-or-winter scalding-hot baths she used to take to keep away the microbes.

But here is the crux of my story: she lived a long life. By

the time she'd reached her eighties, she'd had two heart attacks, and her doctor warned her, 'Dear lady, you're going to have to give up those daily scalding-hot baths of yours, or I'm afraid I'm not going to be responsible for the consequences.' But she wouldn't. She simply could not surrender to those germs, and so she died in the bathtub.

I've never seen my grandmother's death certificate, but I assume it gives 'heart attack' as the official cause of death. I know otherwise. I insist she died of cleanliness.

Now let us turn to professional historians, and see whose version of my grandmother's death they prefer, the doctor's or mine. I suppose a serious historian would have to resort to some historiosophy: the differences between cause, reason, factor, background, motive, urge, consequence, indirect and added contribution, and so on. Or else, the historian – if he or she belonged to the old school – would simply prefer to drop the subject, claiming that the cause of my grandmother's death has no historical significance whatsoever.

This particular kind of incident would be of interest to that particular type of historian only if it was wrapped up in some useful interpretation, or if some kind of meaningful deductions could be drawn from it; although this would depend, of course, on which school of thought our historian belongs to. I'm rather afraid that most historians would tend simply to close the file on my grandmother's death, pronouncing it 'of no public interest'. There are, of course, other historians, those who follow the 'Total History' school, who would make an attempt at fitting the issue into some kind of context, as opposed to simply dismissing it.

Well, it so happens that I am quite interested in this case, and not only because it concerns my own grandmother. Her expression 'the Levant is full of microbes' fascinates me. Not because of any microbes or because of some truths about the Orient. The Middle East probably has no more microbes in it than did that part of Eastern Europe where my grandmother was born. Yet her expression may contain

certain clues about herself, and possibly about some of her contemporaries, immigrants, refugees; people with backgrounds, upbringings, feelings and sensibilities similar to those of my grandmother. Allow me, therefore, to re-open the file on my grandmother's death, long closed for 'lack of public interest'. Was it cleanliness; or was it a heart attack?

Turning now from historians to philosophers, let us assemble here a council of consultants, a forum of esteemed thinkers; I shall ask them what, in their opinion, killed my grandmother.

Leibnitz leans towards the doctor's conclusion, death by heart attack, as inscribed on the death certificate, in line with his 'law of sufficient reason'. Spinoza, on the other hand, would probably recommend that I trace, rationally, as far as my intellectual faculties allow me, the chain of causes and results, a chain in which the first and ultimate source is God, who is His own cause, and is the cause of all causes. From David Hume I learn that the concept of causality in general and the search for the cause of my grandmother's death in particular, represents neither reality, nor truth. Rather, it is a manifestation of certain all-human psychological-cognitive needs, deeply rooted in our own associative habits. Hume, therefore, would suggest that we be precise and say that Grandmother died while having a bath and after suffering a heart attack. In other words, she took a bath, she had a heart attack, and then she died. All the rest, according to Hume, is no more than 'probability, acceptability, belief'.

I turn now to Immanuel Kant, who, from the start, didn't really want to look into this case; he had never been much in the habit of looking at women, either alive or dead, and certainly not elderly ones in bathtubs. Refraining from delving too deeply into this particular argument, Kant reminds me that, in the absence of the regulatory use of the ideas of pure reason, we humans would be unable to structure our universe out of experience, and that according to the principle of causality, which determines that all changes

21

occur in harmony with the rule which connects cause to consequence, all twin occurrences are intertwined by an objective and irreversible order of 'before' and 'after'. So much for Kant, who, as usual, succeeds in making a concentrate of the whole affair – the heart attack, Grandmother's obsessive cleanliness, the hypothesis that this obsession was rooted in fears, possibly based in her own Puritan upbringing, joined to other factors whose origins lie in historical and sociological circumstances, themselves originating in even earlier and deeper-rooted factors, historical, cultural, psychological, genetic and so on.

I approach Einstein, who, more or less in his words, says (I quote from memory): 'The question of determining the causal unavoidability of a single event is, in principle, indeterminable – and therefore it is meaningless to question the cause of an individual occurrence.'

And that brings us back to square one. I could just about bring myself to agree with Einstein that the question is, in principle, indeterminable, although, with all due respect, I refuse to accept his verdict that, being indeterminable, it is also meaningless.

Where were we? Still on the case of my grandmother's death: may I or may I not maintain that she died of cleanliness, notwithstanding the heart attack which, according to her death certificate, was the official cause of death?

Facts, I say, are often the worst enemies of truth, and, in any case, at the heart of our matter lies the complicated relationship between metaphor and image, fact and truth. And by the way, since we're on the subject of naive, unanswerable questions, we may as well ask ourselves what are the similarities and what are the differences between the historian's (or, at least, a particular type of historian's) interest in the case of my grandmother's death, and my own, somewhat different, interest in it? Her obsession with purity and her description of the 'Levant' could both serve as a good basis for an historical study of the unfortunate image of the Middle East, as seen by people who came to it from

places which were, after all, no less microbe-infested, not to mention other trials, but, as far as I am concerned, Grandmother interests me because she was my grandmother, not simply as a case study for better comprehending the Middle East, the immigrants to it, or their images of it.

The fact is that images, even false, distorted ones, can indeed kill people, and not just obsessive ones like my grandmother. Images such as the 'promised land', or 'the land of milk and honey' could and did make many people get up and go and change their lives. Incidentally, I happen to believe that most of modern Israel's architecture is based on one mistaken verse in an old poem by Bialik, 'Ode to a Bird'. This vast architectural catastrophe which has carved Israel's destiny as a land full of ugly edifices, originates in just five words in that Bialik verse: 'The land of everlasting spring'. Bialik, of course, had not yet set foot in this country when he wrote that, he was just fantasizing. But for the almost one hundred years since then, many of our Israeli architects have been building everything here according to Bialik's fantasy, ignoring completely the fact that, each year, we are obliged to endure seven or eight months of cruel summer, and four real winter ones. We have no autumn worth mentioning, and only about one day of spring, which, if we're lucky, falls on the tree-planting festival of Tu B'Shvat.

Worlds away from springtime and architects, other metaphors and other images might well have paved the road to the gas chambers. Different kinds of images and conceptual fixations have all contributed to the persecution of Jews and blacks and others, to discrimination against women, intellectuals, homosexuals, to the oppression of believers and of infidels. And, as we are speaking of the strained relationships between fact and opinion, truth and simile, between image and form, I certainly have no intention here of dividing our territory along disciplinary lines; making our historian the commander-in-chief of the forces of facts, for instance, and the philosopher or the theologian the chief of

staff over truth. Of course not. This kind of division seems to me to be both impossible and ridiculous, and anyway, my grandmother's 'microbe-infested Levant' belongs firmly in her own imagination, her prejudices and her character. Her death in the bathtub is a fact. And what about the truth? Well, truth is a mystery which I am not about to resolve here, but which I am at least trying to portray.

Truth, of course, is connected to facts, although it contains much more than just a collection of facts. Truth, while related to images and conceptions, is not necessarily synonymous with them. This is quite clear to almost everyone, so long as we remain within the spheres of ethics, aesthetics or metaphysics. In the so-called 'exact sciences', there is still – or should I say, there is now – a tendency to see the adjectives 'real', 'factual' and 'true' as almost synonymous.

Unhappily, and inwardly sighing, I am obliged to make do with the cautious conclusions that truth is that which we accept as being truth; unlike fact, which must pass an empiric test; and yet again, unlike image and perception, both of which are based on habitual outlook, attitudes, and cultural concepts.

Now that we have overcome the temptation to leave facts safely with the scientists and historians, how can we tell the difference between a page written by an historian and one written by a storyteller? Well, there is not always such a difference. Some historians are also storytellers, and some storytellers, as well as being tellers of stories, are historians. Let us exclude, in this context, the words 'structure' and 'fiction'. I particularly do not wish to hear the word 'fiction'. Take a look at Tolstoy's *War and Peace*, at those pages describing the Battle of Borodino. Obviously, they differ from pages written by historians describing the same battle. But in what way? Tolstoy's battle is certainly no more nor less structured than is the historian's. No matter from what angle you look at it – literary, historical or military – the historian's description is structured. There is structure in every human thought and deed – and, as comrades Freud

and Jung have pointed out, even in our dreams. Moreover, the Battle of Borodino was, in itself, a structured event. And both the historian's and Tolstoy's rendering of it are structured: both novelist and chronicler may well have chosen, for example, to disregard the fourth tree on the left, that one at the foot of the third hill over there. They might just as easily have both decided to overlook the extremely unhappy marital relations of General Kutuzov's uncle on his mother's side, although, who knows, even this particular unhappiness may have had some indirect, marginal bearing on the course and consequence of that specific battle.

To be sure, Tolstoy's ideas of what was and was not relevant must have differed from those of one historian, and the ideas of that historian may well have differed vastly from what was considered relevant by yet another historian. A different historian, or novelist, Dostoevsky for example, would have used totally different criteria to measure what was and what wasn't worth being included in the description of the Battle of Borodino. Just imagine then, the Battle of Borodino according to Dostoevsky, or Chekhov. Or how do you fancy the thought of Gogol going to Borodino. . . ?

So, what the historian and the novelist do have in common is that they both use the criterion of relevance, they are both selective with their facts, although in different ways; both of them supply us with an interpretation, not a full recording. They both select and emphasize; each chooses his or her own focus.

Shall we at this point conclude, therefore, that historiography and storytelling differ only in degree, but not in essence? That they differ from each other only as, say, a dentist differs from a dental healer? No, let's not be too hasty in giving up the hope of uncovering the differences in these two kinds of literary craft, in these two kinds of uncertainty.

Perhaps we ought to try to locate the difference not in the presence or the degree of structuring, not in the dubious term 'fiction', but elsewhere: in the recipient's, in the reader's willingness to accept the text with uncertainty, to accept the

'openness' of the description vis-à-vis 'the real world'. Thus we may try to differentiate between a literary narrative, a chronicled narrative, a text written by a physicist, by a biochemist, an anthropologist – and in the different ways in which these texts are received by their readers.

But let me digress here: let us first take the English term 'fiction', which is virtually untranslatable into Hebrew. There is the new scholarly term, '*bidayon*' – a derivative of the word '*b'daya*' – 'falsehood'. This is the Hebrew translation of the word 'fiction', used for academic purposes only. Hebrew has '*sippur*' ('story'), and '*divrey ha'yamim*' ('historic chronicles'), but no distinct line is drawn between these two terms, thus the episode about King David, Bathsheba and Uriah, for example, is called a '*sippur m'divrey ha'yamim*' ('a story from the historic chronicles'). In Hebrew, chronicles are conceived of as a series of stories. The Jewish sage-interpreters of the Scriptures claim that 'Job never in fact lived, had never been created, except as a fable.' What they are actually saying is that Job does exist, but as a fable. No one in our Jewish sources has ever defined the Book of Job as narrative fiction, because fiction, as we know it in Hebrew, has the ring of immorality to it, and is almost synonymous with 'lying'. Libraries in Israel categorize my own books not as 'fiction', but as '*sipporei*', which can be translated as 'narrative prose'.

Could Aristotle perhaps hold the key to what we are trying to uncover here? Poetry, says Aristotle, is more philosophical than historiography, and superior to it, for poetry deals with universal matters, whereas historiography focuses on definite objects and events.

But is this really so? Just a few minutes ago, we were turned down by an historian, by a certain type of historian at least – one who distinctly refused to concern himself with my grandmother's death, claiming that this death is a private event, a case of 'no public interest'.

Furthermore, Aristotle says that 'poetry deals with things not as they actually occurred, but rather as they ought to

have taken place', which is probably the most extensively quoted phrase in the whole of aesthetics: '. . . things not as they were, but as they ought to have been'. Still, Aristotle forgets to tell us how, exactly, things 'ought to have been'. It is not easy to concur that Herodotus, when describing the Peloponnesian War, is only concerned with particular, specific circumstances, whereas Homer, going to a great deal of trouble to draw for us a most detailed picture of Odysseus's scar, is actually disclosing through this scar something 'universal', or merely pointing to things 'as they ought to be'. Or let's take Richard III, a few centuries later. Is he chronicled 'as he really was'? And in what sense does Shakespeare re-create him 'as he ought to have been'? And what's with this 'ought', anyway?

Indeed, Shakespeare's Richard suffered a bitter fate as a result of his awful character, which was Shakespeare's way of casting a certain, possibly moralistic, mould, on the concept of fate. But what, on the other hand, was the real Richard's fate? Was it also a consequence of anything, and, if so, of what? I, sadly, am going to try to resolve that one by saying that the answer lies in the eyes of the beholder. A romantic historian might bestow on Richard III one set of attributes, whereas a historian with Marxist leanings would strip away those romantic attributes and replace them with a different set altogether.

And after all is said and done, everything *is* real. Lies are real. Not factual, not genuine, but real they still are. So are dreams. So are inventions, and nightmares and fantasies and pain and fear and desire. Macbeth is real, and so are the Emperor's new clothes, no less than Jacob's ladder and Ivan Karamazov's demon and the continent of Atlantis and even the part-woman part-fish sirens who seduce sailors out at sea; they, too, are real, because they all affect or have affected the world, just as the obsession with cleanliness and the terror of microbes brought about my grandmother's death. The terror, not the microbes.

Let us spend a couple of minutes talking about pain. I

have just mentioned pain as part of a catalogue of various items. Pain is a very popular subject with poets and story-tellers. Probably their favourite subject of all. Historians, on the other hand, seem to have no particular taste for pain. What, then, is pain? Is it something real? Or is it unreal? Is it structured? It's a silly question, really, because all we have to do is bite the tip of our tongue for pain to be one hell of a real thing, real enough, in fact, to make the rest of reality positively pale. In an instant, our pain can become more real than the entire Napoleonic Wars. Incidentally, pain sometimes comes in waves – like toothache – in which case it even possesses a structure. Admittedly, the reality of pain will continue to be problematic, since there exist no quantitative methods of measuring it (or do there?). But it will continue to be problematic also because of language limitations in communicating pain, and, when contained in words, pain tends to become metaphoric, metonymic, recruiting verbal reinforcements from other fronts. Language finds the expression of pain a painful business in itself.

Is pain, then, a matter for the historian or the poet? Is pain real enough even though it cannot be measured? Or should pain remain within the realm of uncertainly, since it can't be 'taken', in the way a temperature is taken? Obviously, when someone is hurt, he or she can only describe the pain in the first person singular. And when something hurts, not only is it real, it is the reallest reality in the world. The cause of the pain may be undetermined, the way to stop it unknown, but the pain itself is an island of certainty in an ocean of uncertainty.

Look at Napoleon's belly ache. Wasn't it relevant to the results of the glorious Battle of Waterloo? And how exactly should the historian deal with this particular belly ache? And, by the same token, how should a storyteller deal with it? Where, in the sphere of reality, does the belly ache take place? Since clearly it cannot be photographed, recorded or documented (only its consequences can), it is reasonable to say that pain exists in the mind and in language; which

means that pain exists, at this moment, exactly where Napoleon exists, and God, and the brothers Karamazov, and Jacob's ladder, and the Wizard of Oz, and my grandmother and her Levantine microbes: they all exist now in the mind and in language.

Fear not, I have no intention now of stepping into the eternal hunting grounds of the metaphysicians and theologians, of the epistemologists and linguists and semioticians – I merely took a momentary peek over their fence. One thing which historians and artists do seem to have in common, though, is that whenever they dare to venture into those grounds, they rarely return home safely.

So, back to square one. What killed my grandmother? Where is the line dividing fact and truth? Where can we find our cherished certainty, and how cherished is it, after all?

First, we have already established that distinguishing between real, unreal and surreal is of no help to us, since, one way or another, everything is real. We saw, also, that differentiating between structured and unstructured is also useless, as both Shakespeare's Richard III and the historic Richard come to us well wrapped-up structurally.

Let us, then, try a different approach: the use of words. What is contained in language and in what way does it attempt to convey and activate things? Prose and poetry at best serve as over-used language's oxidation pond, through which hackneyed, worn-out and abused expressions and idioms can be recycled into the living language. Sometimes, literature can rejuvenate the world for us by injecting into the spoken language brand-new verbal combinations, making us see anew, as if for the first time. As Natan Alterman said: 'A worn-out view, too, had its moment of birth.' Yehuda Amichai says in one of his poems: 'Rest your case. Your case has run with me all the way.' And so that standard legal phrase 'rest your case' receives a slight electric shock, is rejuvenated, taking a deep breath and wiping the sweat off its brow after the long run. And here, I believe,

is where the historian and the poet must go their different ways, waving, or not, 'bon voyage' to each other. Unless the historian happens to be also a poet or a storyteller, in which case there is no need for them to wave.

Or try another example: the profoundly poetic Hebrew expression, '*at motset hen be'einai*'; in English, 'you find grace (or beauty) in my eyes', which is the commonest form, in Hebrew, of saying to someone 'I like you' (or 'I like it – '*zeh motse hen be'einai*'), which has worn thin, become trite, through so much use and misuse and by being taken for granted. Listen to this expression verbally; it contains, of course, the fascinating notion that grace – any grace – is to be found (or not) only in the eyes of the beholder. You don't find grace in my eyes? Then perhaps you should do some deeper searching. Or you might try finding your grace in someone else's eyes instead. In any case, you ought to work at finding your grace in my eyes – and I, in finding mine in yours.

So, this idiom might well find itself obliterated through over-use, everyone saying it several times a day, but only a few, if any, taking the trouble to linger over it, to ponder over its meaning. And yet this lovely expression, if oxidized through a rejuvenating context, may still become electric. Which is exactly where, as I have suggested, lies the grace within the eyes of the beholder, and where the historian and the poet part ways. From here on they will follow different paths towards different kinds of uncertainty. True, a historian would often like to find grace in the eyes of his or her readers, but I have yet to meet the historian who would bother to record that the expression 'I find grace in your eyes' finds grace in his eyes.

Living with uncertainty means permanently existing within an open-ended condition; to have an artistic experience means also to have this experience as an open-ended condition. To stop asking our society's ever-popular question: 'How is it going to end?', to accustom ourselves instead to living with uncertainty. It is indeed part of human

nature to be forever seeking the 'bottom line', but if taken to extremes, this urge can fuel all kinds of fires of fanaticism. Throughout history, zealots have always striven toward a 'conclusion', a 'certainty', a 'bottom line'. An open-ended condition, an atmosphere of doubt, the acceptance of this uncertainty, not as an unavoidable evil or punishment or banishment from the Garden of Eden, but as something fruitful, a blessed condition, provide one with constant stimulation to seek, to create, to define and redefine, to make full use of one's freedom.

Well, then, the fact is that my grandmother died of a heart attack. It is no less a fact that she died of cleanliness. Although I hope the second fact is expressed in such a way as to cause the reader a slight tremor above and beyond the information itself. The nature of this tremor, and my insistence that it should be a slight one, are, perhaps, subjects for another discussion.

I'd like to start moving toward a summing-up of this particular discussion, thus: a scholar, an historian, a researcher, a scientist, are all concerned with facts and activities and the possible ties connecting them, with components of reality and the possible ties connecting them. By 'components of reality', I refer also to the ladder in Jacob's dream and to my grandmother's microbes. A novelist or a poet is concerned with exactly the same things: phenomena and ties. They are all – the historian, scholar and researcher on the one hand, and the poet and the novelist on the other – striving to make the connection between characters, events and phenomena as interesting and convincing as possible. At the same time, they would all like to come up with something original, too. The interest and originality are achieved, by both the novelist and the historian, through careful selection and organization of their details, through arranging their facts in certain order and juxtaposition. All are involved in the same game of emphasizing and playing down.

The difference, if there is one, lies perhaps in the willingness to accept uncertainty as a sort of existential certainty: the certainty of uncertainty. The open condition remains so not because we have not tried hard enough to resolve it; it is not only a temporary measure until we are wise enough to find the right answers, nor is it because we are as faithless as all those fanatics are trying to make us out to be. No, the condition is open because we want it to be open. If you really want everything to be nicely closed and resolved, well, there are plenty of doors around; just knock on any one of them and you'll be let in. You'll be all set, then, although you might find it a bit of a problem getting out again.

I return to the poet Yehuda Amichai; when he writes: 'The man under his vine phones the man under his fig tree', he is trying to convey something more. It doesn't matter if the man under the vine literally gets in touch with the man under the fig tree – what matters is the slight shock precisely from this insertion of a buzzing telephone in the middle of a prophetic vision of eternal peace. 'Tyger! Tyger! burning bright In the forests of the night': little information here, yet there is fact, slight shock, reality. And, for the first time in this dissertation, I shall assertively use the word 'truth' – there is also truth. But no new knowledge. It says in Ecclesiastes: 'He that increaseth knowledge increaseth sorrow'. William Blake's tiger, although supplying us with no new knowledge might still be adding some sorrow. Which is perhaps what Kafka meant when he talked about books 'coming, like the blow from an axe, to shatter the sea of ice within our breast'.

And there lies the difference. The rest is literary, or scholarly, sentimentality. Since I began with my grandmother, I should like to conclude with the village idiot. I refer to that same one in Isaac Bashevis Singer's 'Gimpel the Fool'. Gimpel is the fool's name, and 'Gimpel the Fool' is the title of the short story. After suffering many of life's trials and tribulations, Gimpel says: 'The older I become, the more I realize that there are no lies. If something did not actually

take place, it may have happened in a dream; and if not to Hillek, then to Billek; and if not today, then tomorrow, or next year, or in another hundred years. What difference does it make? Many times, when I heard a tale, I thought: it's not possible. And then a year passes, and another, and I hear that that same thing happened somewhere: even fiction has some truth about it, why does one person invent this particular lie, while someone else invents something quite different, eh?'

And so, I absolutely agree with Gimpel. In all the world there is no fiction. There is no certainty, but nor is there fiction. Everything is real. The storyteller and the scholar differ not in the way they both relate to facts, to reality, truth, certainty, but precisely in the way they relate to words.

I'll use one last little metaphor to demonstrate this: the scholar usually chooses words which will make his writing as transparent as this window. The language of the poet, on the other hand, is more in the nature of a stained-glass window. Now, who is to decide which is more precise, the ordinary window or the stained-glass one? Both are precise, each in its own way. Which one 'finds more grace'? This question is superfluous, since we have already determined that grace is in the eyes of the beholder. Which of the two, then, is closer to certainty? The answer to this is that they are both, to an uncertain degree, uncertain. The world as seen through an ordinary glass window is neither more nor less certain than the one seen through a stained-glass window. The light which illuminates them both is, after all, the same light, whether pouring through the ordinary window or through the stained-glass window – a combination of inner and outer light. Just how much of it is inner and how much outer light, I don't know. Anyone who has the answer, is requested to come forward and tell us.

Lecture, Tel Aviv, 1992;
Cambridge, 1993
(*Translated by Ora Cummings*)

From Jerusalem to Cairo

Escaping from the Shadow of the Past

THIS IS NOT a message with yet another 'programme for peace'. It is not written by a politician, and it contains no new proposals about borders, autonomy, or security. I hope that politicians on all sides will find in their hearts the patience, imagination, courage and wisdom needed to bring the peace agreement to full and final fruition. That is their task.

There is one task which the politicians cannot perform and which they are under no obligation to attempt, and that is to scrutinize the past, the sources of hatred and the well-springs of suspicion, with the aim of clearing away the stereotypes and understanding the soul of the other side. This task falls to the lot of the poets and thinkers, the writers and intellectuals. The politicians must not be allowed to touch the painful past, in case they make of it an explosive which is liable to endanger both the present and the future. Politicians are under an obligation to erase the past.

But intellectuals cannot erase it. Poets have to reopen the old wounds and squeeze out the pus. Thinkers have to interpret the ideology of the other side, as it is in reality and not as it is portrayed by the propagandists. Writers are able – and therefore obliged – to lay bare the soul of the man who confronts them, his beliefs, his hopes and his fears. I do not in this article profess to describe the Israel–Arab conflict 'objectively'. I am not an historian, and I do not claim to understand the whole truth. I am a Jew, an Israeli, a Zionist, who belongs to the moderate left in Israel.

I have twice taken part in wars. I was privileged to witness President Sadat's visit to Jerusalem, the signing of the peace agreement and the exchange of ambassadors between Israel and Egypt. I hope to see agreements signed with all the other Arab states, and a fair solution found to the problem of the Palestinians. I am committed to the peace and security of my country. I shall try to explain here a few of the basic attitudes (psychological, ideological, and political) of my fellow countrymen. I hope one day to read a similar document by an Egyptian intellectual or a Palestinian writer, trying to explain to us, not the 'minimal conditions for peace' (that is the task of the politicians), but the feelings and attitudes from which the conflict derives, and which will have to change if peace is to be achieved.

Three Basic Attitudes

Almost from the beginning of modern Zionism there has been a fierce debate over the question of our relations with our Arab neighbours, both inside the country and in the neighbouring states. It is impossible to describe here all the various nuances in this debate. I shall try to give a schematic sketch of three fundamental tendencies.

1. The militant approach may be termed, in the phrase of Vladimir Jabotinsky, the 'iron wall' theory. The Jews, according to this approach, are returning to the land of their forefathers so as to inherit it. It is up to us , the Jews, to create facts and to build up our strength, until the Arabs are compelled to submit to the Zionist reality because of its superior power. There is no hope of compromise or understanding between the two sides until the Jews have erected the 'iron wall' and the Arabs have understood that they are unable to break through it. Only then will the victors be in a position to treat the losers with magnanimity. This approach has been, for most of the period of the Zionist enterprise, that of a minority.

2. The romantic approach, which has also been a minority position in the history of Zionism, is represented by the Brit Shalom ('A Peace Treaty') movement and others like it, and by groups which have inherited its main doctrines. Brit Shalom maintained that without the 'consent' of the Arabs Zionism is either immoral or impossible, or both. Martin Buber and his disciples believed that Zionism conferred a blessing on the Arabs and that we ought to explain this blessing to them, persuade them to be enamoured of the Zionist enterprise, and only then proceed with the enterprise itself. This movement was prepared to entertain such ideas as a multinational state, a supranational state, a federal state, a confederal state, and so on.

The fate of the members of Brit Shalom and their successors was a tragic one. Internally they were accused of obsequiousness and even treachery, while the Palestinians saw them as crafty cynics who were out to cheat the Arabs by camouflaging their real intentions. The movement never succeeded in convincing either the Israelis or the Arabs.

3. The intermediate position, which – forsaking 'historical objectivity' – I propose to call the 'realistic approach', is that of the founding fathers of Zionist social democracy and the leaders of the Zionist bourgeoisie. Chaim Weizmann, David Ben-Gurion, and Levi Eshkol – with varying emphases – shared this approach, which was dominant at least up to 1967.

What is the substance of the 'realistic approach'? Zionism is a movement of national liberation, which has no need of any 'consent' or 'agreement' from the Arabs. But it must recognize that the conflict between us and the Palestinians is not a cheap Western in which civilized 'goodies' are fighting against native 'baddies'. It is more like a Greek tragedy. It represents a clash of two conflicting rights. The Palestinian Arabs have a strong and legitimate claim, and the Israelis must recognize this, without this recognition leading us into self-denial or feelings of guilt. We are bound to accept a painful compromise, and admit that the Land of Israel is

the homeland of two nations, and we must agree to its partition in one form or another.

As I have said, the 'realistic approach' used to be the main line of the Zionist enterprise. Between 1967 and President Anwar Sadat's visit in 1977 the 'militant approach' gained a good deal of ground. At the moment Israeli public opinion is divided. The party divisions in Israel have never precisely expressed the differences between these approaches, and even today the party-political map does not reflect accurately the relative weights of the various tendencies.

Right vs. Right

Zionism is a movement of national liberation. This point is not really understood even by our friends, while our foes tend to reject it angrily. It is this anger that I am trying to defuse. The Jews are not like other victims of enslavement and oppression. We did not wake up in our own land after a long period of oppression and slavery to throw out our oppressors and regain our independence. We do not fit into the usual model of 'national liberation'. For upwards of a thousand years this land was inhabited by Arabs. It was not they, but the Romans, who crushed our independence. It was not they who banished our forefathers into exile. One cannot say that we came here to recover from the Arabs what the Arabs took from us by force.

In any case, Zionism – according to the interpretation which I accept – is not a movement to liberate territory but a movement to liberate people. The word 'liberation' can only be meaningfully applied to people. The purpose of Zionism was to achieve the national liberation of the Jews who had a desperate need of national self-determination and could no longer exist as a religious minority within other nations.

For various historical reasons – emotional, religious, and

cultural – the only place where the Jews were willing and able to establish the framework of a nation was the Land of Israel. And this land was not empty. Why were these emotional, religious, and cultural ties still so strong even after thousands of years? Who would be rash enough to attempt to explain the various national migrations which have taken place in history? Any one-dimensional explanation, be it theological or Marxist-materialist, poetic or strategic or sociological, appears petty and ridiculous in relation to the magnitude of the phenomenon itself: throngs of people migrate from various places to one particular place, to become a nation. And this place is not comfortable or rich; it does not offer promising political or economic conditions; and yet the migration does not diminish. Even the migrations of birds or the movements of animals from an old home to a new one, or from the new back to the old, are phenomena which have given rise to specific scientific theories; but who would dare to claim that he had found one simple, satisfying explanation?

The agonies of the Jews in most of the countries where they were dispersed, especially in the last hundred years, shattered their hopes of divine salvation, as well as their hopes of being rescued by liberal, humanist, or socialist progress.

There were some Jews who, because of suffering and persecution, abandoned their Judaism.

There were some Jews who accepted suffering and persecution as part of the natural world order, as the will of God.

There were some Jews who had learnt to flee from refuge to refuge, to wander from country to country.

And there were many who decided that the only way out was to become a nation like all the others. They felt they had to return to their home, and acquire what any nation has: territory and sovereignty.

For these Jews 'home' meant the Land of Israel. One may attempt to explain this in Marxist or in mystical terms; the

fact is that those Jews who had made up their minds to return home came to Israel. Like a bird coming back to its old nest or a wounded animal returning to its lair.

But the founders of 'realistic Zionism' knew that the Arabs would not accept this phenomenon, whether through force of arms (the 'iron wall') or through fine promises (the 'romantic approach'). They perceived the elements of tragedy which are woven into the conflict between two rights.

What is the right on the Zionist side? It is the right of a drowning man who takes hold of the only available raft, even if it means pushing aside the legs of the people who are already sitting on it so as to make some room for himself . . . so long as he only asks them to move up, and does not demand that they get off the raft or drown in the sea. A Zionism which asks for a part of the land is morally justified; a Zionism which asks the Palestinians to renounce their identity and give up the whole land is not justified.

I blame the Palestinian national movement for insensitivity to the suffering of the Jews, for callousness ('It's a European problem which doesn't concern the Arabs') and for lack of imagination; but I do not blame them for refusing to welcome the Jews with a deferential bow and hand over the keys of the land.

I blame the militant Zionists for disregarding the identity of the Palestinian population; but I cannot blame the Jews for seeing the Land of Israel as their last possible life-raft.

All these considerations lead me to accept the moral (and not merely pragmatic) rightness of the idea of partitioning the land between its two nations. The task of fixing the borders of the partitioned land I leave to the politicians.

What is Delaying a Comprehensive Solution?

On both sides there are elements which refuse to respect reality. On the Israeli side we have the militant approach,

the 'iron wall' theory. On the Palestinian side there exists an obsession with 'absolute justice'. I have repeatedly stated in the course of numerous debates that I refuse to regard the PLO as a 'Palestinian liberation movement'. Not because they shed innocent blood – who has not shed innocent blood in the pursuit of liberation from foreign domination? – but because the PLO is not content simply to liberate the Palestinians. It wants to liberate me as well. That is the long and the short of it. It is as if the FLN (Front de Libération Nationale) had decided not to be satisfied with the liberation of Algeria but wished to liberate France from the shackles of Catholicism. Or as if the Vietcong had decided to liberate America from the yoke of capitalism. Arafat claims to want to 'liberate the Jews in Palestine from the Zionist yoke'. This is an absurd position which has no precedent in any liberation movement. Arafat claims the right to determine my identity for me. He wishes to liberate me from myself.

If the Palestinians were to come along tomorrow with a proposal to recognize us and our independence and our nationhood on condition that we recognized them and their independence, I should be prepared to embark at once on the painful and difficult negotiations towards a peace settlement. For 50 years now, the 'realistic tendency' in Israel has been prepared to accept the partition of the land between the two nations, though with a heavy heart. But the PLO does not recognize the fact of the existence of two nations. It trumpets forth slogans about 'handing back the stolen lands' and about 'absolute justice' (understood in its own terms).

This attitude takes on a frightening dimension if we compare it to that of the militant Israelis who are not prepared to recognize the existence of a Palestinian people.

There is, however, no simple symmetry in this opposition. Good Israelis are prepared to envisage partition, sensible Arabs are prepared to envisage mutual recognition; but the extremists on both sides make no allowance for compromise.

There is no symmetry: the fundamental position of the PLO resembles the *militant* position in Israel. There is no parallel on the Palestinian side to the *realistic* position in Israel. That is why so far we have heard no real voice from the Palestinian side supporting partition as a fundamental and right solution (not as a stratagem or a stage on the road to the destruction of Israel).

So it is too with the 'theatre critics' of the conflict, our European friends who judge us all from a safe distance. They say that the Arabs (Egypt excepted) have a 'Saladin complex' and the Israelis have a 'Massada complex'. The Palestinians suffer from an obsession with destruction and the Israelis from an obsession with insecurity. Conclusion: both sides are slightly deranged.

I reject this comparison. There is no symmetry between a destruction complex and an insecurity complex. There is no symmetry between the position of Begin (which I oppose) and that of Arafat, Assad, and Saddam Hussein. A destruction complex and an insecurity complex are not on the same level, either from the moral or the psychological point of view. Moreover, the Israeli insecurity complex is, to a large extent, a product of the 'Saladin complex' of part of the Arab world.

There is no alternative to reconciling oneself to the fact that as a result of an historical cataclysm which has taken place over the past 70 years the land is divided between two populations with distinct national identities, neither of which is able – or entitled – to eliminate the other. President Sadat and his people realized this, created a conceptual revolution, and also brought about a conceptual revolution among us. With President Sadat's visit to Jerusalem many of the 'militant Zionists' softened; and by means of this great emotional breakthrough Israel gained recognition and peace and Egypt recovered the Sinai Peninsula and gained peace. A similar emotional breakthrough needs to come about in the rest of the Arab countries, and first and fore-

most among the Palestinians, before we can celebrate the end of the whole conflict.

The Shadow of the Past

The real calamity is that both sides are unable to look each other in the eyes, to look into each other's souls. The leaders of Israel and Egypt have signed a peace agreement (March 1979); the Israeli and Egyptian peoples have not yet arrived at a cordial mutual understanding. Here, perhaps, is the key to the depth of the tragedy.

What does the Israeli see when he looks at the Arab? Frequently he sees the shadow of his persecutors and oppressors in the grim past: Cossacks, dressed now in Arab robes and headcloths, come to continue the work of the pogrom-makers in previous generations, to murder, rape and pillage.

What does the Arab see when he looks at the Israelis? Frequently he sees in them the shadow of his former persecutors and oppressors. Not persecuted Jews trying to be a nation like all the rest, but a continuation of the wily, arrogant, European colonialist and imperialist, come to enslave the East and exploit its wealth by means of technological superiority.

The shadow of the past hangs over this whole conflict. It is Europe, which shed the blood of the Jews, persecuted and annihilated them, Europe which oppressed and humiliated and exploited the Arabs, that is responsible for the situation where Israelis and Arabs are unable to look into each other's eyes and souls without seeing the shadow of the past. The Arabs and the Israelis are both peoples who have experienced humiliation, subjugation, and suffering. But it is only in the framework of Marxist mythology, or in the plays of Bertolt Brecht, that the persecuted and humiliated become 'brothers' and forge links of mutual solidarity. In the lives of individuals and of nations the fiercist conflicts of all are

often those between two victims of the same persecutor. The Arabs and the Israelis are two nations who have suffered anguish and humiliation at the hands of Europe. It is tragic that each looks at the other and sees only the face of their common enemy.

Fear and suspicion beget foolishness.

'If you agree to accept our formula,' many Arabs say to Israel, 'we shall spread the shelter of our protection over you, you will be free to worship in your own way, and the sword of Islam will guard you from all harm. . . .' Such words fuel the flames of the psychological trauma of the Israelis, because they recall what was said to them in the past, with terrible consequences.

Meanwhile the Israelis, for their part, often say something no less obtuse and dangerous to the Arabs: 'If only you will accept our peace formula, we shall come to all the Arab countries with our sophisticated scientific and technological expertise, we shall improve your agriculture, set up industries, and bring you into the modern age.'

It seems to me that remarks like these from the Israelis only fuel the flames of the Arab trauma. The Arab nations have heard this tune before, precisely from their most wily and brutal oppressors.

And so, before our eyes, both sides are adding fuel to the flames of the suspicion, fear and nightmares of the past. If only it were possible to banish this horror to the place where it belongs: the stage. Tragedy. Comedy. Farce.

It is the propagandists on both sides who are responsible for this idiocy. But blame also attaches to the poets, the writers, and the intellectuals who do not attempt to break down the barriers of the stereotypes created by propaganda. In Egypt, in Israel, and among the Palestinians there ought to be thinkers who can understand the mind of the other side and will tell the politicians and the propagandists what must not be said and how to avoid reopening old wounds. The Israeli does not want to hear remarks about the protection of Islam or about freedom of religion within the Arab

world. And the Arabs do not wish Israel to come and modernize them and change their way of life and their values.

Is it possible that writers and ideologists on both sides will perform this task? Will the poets undertake to do what is beyond the power of the politicians, to delve into the depths of the other's soul, to voice his fears and traumas, to concern themselves not with questions of borders and arrangements but with questions of suspicions and anxieties? What is the reason for each side characterizing the other in terms of treachery, cunning, savagery, and arrogance? What are the roots of the sense of injustice and humiliation on both sides?

Above all, we are all now in need of a measure of mutual sensitivity and creative imagination, so that agreement between politicians can open the door to reconciliation between peoples. Sensitivity and creative imagination will help us to find a way which does not endanger the existence of Israel and does not involve exploitation and humiliation for the Arabs.

Is such a way possible? I have no simple answer. But the real question is this: Is it possible that there is *no* such way – and in that case, where will it all end?

Encounter, 1982
(*Translated by Nicholas de Lange*)

Between Europe
and the Negev Desert

HERE IN ISRAEL, writers pretty much enjoy (or should I say suffer?) the social status which film stars have in other countries. This is both a Jewish and Eastern European tradition. People look upon writers as pseudo-prophets, although of course the writers can never come up with the goods. Writers are the ones who are supposed to have all the answers. Israel is probably the only country in the world where a top newspaper's leader pages will attack the hero or heroine of a novel because he or she has fallen in love with an Arab at the wrong time. The point here being that this would be in a leader, not in the books pages.

Israel is a country where the Prime Minister will often invite a poet or a writer to a personal late-night tête-à-tête in order to discuss an important matter of conscience. Indeed, I have done this myself several times. The Prime Minister will ask the writer what's gone wrong with the nation and where it should be heading. He will admire the writer's reply but of course ignore it just as readily. The reality is that poets and writers do not have a major impact on politicians. Israel is traditionally the land of prophets but even they were never particularly successful in influencing politicians, so it would be unrealistic to expect that present-day writers should do better than the prophets.

Even so, writers do have a certain degree of significance, and people pay attention to what they have to say. If, tomor-

45

row, I were to comment on the state of Israel's roads, it would become a talking-point in the newspapers. Am I an expert on infrastructure? On transport? No – it's simply because it was a writer who made the comment. Everyone here knows the names of the more important writers, and it's highly likely that a taxi-driver will have read your books.

The Peace Now movement, to which I belong, is not a party but rather a voice, and it expands and contracts according to the current climate. When there is a clear prospect of peace, then Peace Now becomes active: we hold meetings and demonstrations, and the whole country hears about it. Equally when there is a threat of war, we come to life. There are no membership lists, nor is there an elected leadership. Peace Now is a think-tank which unites left-wing radicals, liberals from the centre, conventional Zionists, religious people and everyone else of the view that Israel should never attempt to annex the Occupied Territories, even in the event that suddenly, overnight, the Arab countries discovered deep down in their hearts that they were really Zionists and decided to offer us these Territories on a silver platter: 'Take them, they are yours'. Even then we would be saying 'No thank you', because these Territories are densely inhabited by human beings who do not want to be Israelis. And there is no point in forcing people to be Israelis if they simply are not interested.

Our movement holds another belief: we are only prepared to go to war if the life of the nation is at stake. Only a threat to the existence of Israel can justify a full-scale war. Of course, there is debate as to how one assesses the prevalent danger to Israel and what the actual threat to her existence is. But no one debates the fact that the wars we led in 1948, 1967 and 1973 were a matter of life and death. Had we lost these wars, Israel would not exist today. By contrast, the Lebanon War was optional. Begin, the then Prime Minister, introduced the term 'optional wars' as opposed to those wars which are carried out with your back against the wall. Even the hawks and their supporters are

agreed that the Lebanon War was not a matter of life and death, although they do say that the danger may have increased with time and that it was therefore right to initiate that war. This, clearly, is a dubious argument because in that case we should also declare war on Iran which might one day also be a danger to us, and in fact we would have to fight against all those who wish us dead.

One can't compare Peace Now with the European peace movements. We are 'peaceniks', but we're no pacifists: most of us involved in Peace Now have at one time or another been on the battlefield – and if the very worst were to happen and we found ourselves again with our backs to the wall we might fight again. We do not share the Western attitude of 'make love, not war', or the sentiment that, during the Vietnam War, led the American peace movement to view the Vietcong as the 'good guys', and their own countrymen as the 'bad guys'. Virtually no one in Peace Now believes that the Palestinians in the Arab–Israeli conflict are the 'good guys'. They are entitled to self-determination and their national independence, but they are not entitled to a medal for good behaviour. Personally, I've never believed that independence is something which only well-behaved people may have. If that was the case, then three-quarters of the nations of the world should have their independence confiscated, and Germany and Austria perhaps for ever.

But it's not a question of good or bad conduct. It's a question of survival, of the survival of everyone.

Peace Now, therefore, is not a pro-Palestinian movement, and neither is it a pacifist movement. It is, rather, a group of people who believe that the only solution to our conflict with the Palestinian people is in a calmly and fairly thought-out separation, like a separation after a failed marriage. Separation means that we have to split up our home. And since this is a small country, we have to decide who gets which bedroom, and agree on a cleaning rota for the lavatory. After this separation – and by separation I mean the

setting up of two independent states – it will perhaps be possible to talk over a cup of coffee. Perhaps, after sufficient time has passed, we will be able to laugh together about the past. We might even one day be able to set up a Middle Eastern Common Market, even some kind of federation. But it won't be possible to do that straightaway. To tear down the Berlin Wall and hug each other is not so easy in our country. Here it isn't a question of a people divided by a wall, but rather a question of two peoples, two communities, who have been spilling each other's blood for seventy years. There is mistrust and frustration, and both communities must spend some time alone, at least for an initial period.

It's difficult to say how big an influence on society Peace Now has. It certainly isn't negligible. If we take a public standpoint this does not have a direct political effect. But the emergence of Peace Now in 1978 did make it possible for, the first time, for Begin to sign the Camp David Agreement with Egypt. All in all, Peace Now represents the opinion of about half the population.

Yitzhak Shamir had indirect talks with the PLO throughout 1991: he would go to the Americans and ask them to pass things on to the PLO, and the PLO would go back to the Americans and relay their ideas to Shamir, and so on. This was crazy, since in this way a local call merely becomes a long-distance call and has little effect. Why telephone from Jerusalem to Jerusalem via Washington DC? Of course, it was a question of principle for Shamir, but a principle I can neither share nor support.

Although I have a reputation in some circles in Israel for being a dangerous radical, I've never considered myself to be a radical but rather a political evolutionist. I believe in gradual solutions. We should come to an agreement with the Palestinians over the division of land. Over a period of five or ten years, they could obtain their independence. During this period emotions could cool off and various Israeli fears prove unfounded. I do not believe for one

48

minute that Jerusalem should be divided by walls and barbed wire. In Jerusalem, each individual would be able to choose his nationality, perhaps through the setting-up of half a dozen sub-districts: for ultra-Orthodox Jews, for Armenians, and so on, but the city must remain united. I have already suggested this solution to Israelis, Palestinians, Europeans and Americans, and since all were so opposed to the idea, perhaps it might work.

At the moment, there is anger and frustration rather than real hatred between Jews and Arabs. Again, it is this Western sentimentalism, rooted in Christianity, which holds that the first step should be to dissolve the anger and the second step to make peace. Normally it is the other way round. First a political agreement is made and only then do the stereotypes begin to disappear and the hatred begin to die. This is exactly what has been happening in Europe. It is not a sudden outbreak of love between the peoples of Europe which has in recent years made this continent a relatively peaceful place, but the other way round. First there was a political agreement between countries, and only then did the economic reality remove instinctive behaviour.

What you also have to consider is that the Middle East is a highly volatile part of the world where emotions run high amongst Jews and Arabs alike. It doesn't take much to ignite passion. Only months before President Sadat visited Jerusalem in 1977, the Egyptians were saying they would never agree peace with the 'Zionist entity'. Most Israelis were saying they would never hand back the whole of Sinai, not even for the sake of any peace accord. This 'never' and 'for ever' lasted a few months. So I've realized that when people in the Middle East say 'never' or 'for ever', they mean something between six months and thirty years.

Until five years ago, a solution to this conflict did not depend on us. Now, after seventy years, fifty per cent of the onus lies on Israel to resolve it, because the Palestinian position has changed. For seventy years they were saying that there should not be an Israel. They really did believe

that they only had to rub their eyes and Israel would vanish like a bad dream. Now they are saying that they would be willing to consider entering into a form of co-existence with Israel. The conditions are very tough, but it is now time to do deals. The anger, the frustration and also the fanaticism of us Israelis are rooted in the fact that, for seventy years, we have been under a kind of collective death sentence. Under these circumstances there was not much one could do besides defend oneself or prevent the conflict from escalating. However, now that some Arab countries are in favour of a co-existence with Israel, we have to talk to them.

There are too many clocks ticking here at the same time. Arab fundamentalism is one of them. Perhaps the present fairly moderate stance of the Arab governments is a reaction to fundamentalism. Perhaps Arafat could now be elected, but the only way this can be tested is by free elections. Since at the moment he would most likely be elected into office, such elections should be organized as soon as possible. But whomsoever the Palestinians do elect would be Israel's partner at any talks, whether we like him or not.

I haven't belonged to a political party for ages now. I have often supported the Labour Party or other left-wing parties. I go to demonstrations, give lectures, write articles and essays. But I was never a professional politician, I have never stood for office. I'm not qualified for that because I would not be able to pronounce the words 'no comment'. When I get very angry I make a sudden guerrilla-style attack from the bush and then disappear just as quickly. But I could never be a regular soldier. I'm unable to spend my life in meetings discussing tactics. Political parties are like forms of transport to me: as long as they are going in the same direction as me, I'll use them. But I don't have any emotional attachment to any of them.

By contrast, I have a very deep-seated attachment to the early Zionist socialists, and my intellectual and emotional views are rooted in their ideology. They had a much better grip on things than the Marxists and other European social-

ists. The seventy-year-long disagreement with the Arabs caused so many rifts, and it wasn't possible to make the early Zionists' dream of turning Israel into 'a light unto the nations' a reality. They had a very stark view of human nature, not a particularly optimistic one. Unlike the European socialists, they never assumed that when social conditions change, people immediately become better, and that greed, ambition or selfishness automatically disappear. On the other hand, they never allowed themselves to be seduced by Marxist simplification: that you must open people's eyes by force in order for them to see the light. They believed that not all people are created equally, but that all have an equal right to be different. They also believed in the importance of founding small voluntary social cells, rather like extended families, in which people would operate on the basis of decency and pride, rather than achievement and material reward. If people know who they are working for, if they are working for friends in an immediate social environment, then they'd be ashamed if they exploited them and be proud when they made a contribution. Hence the early Zionist socialists' belief that shame and pride could be more important in social life than material reward. And they were no ascetics. They never believed that one person should be as poor as the next. Why not all be equally rich? They never believed that socialism need come from above, from the state authorities and state bodies. To some extent, these people were anarchists. I would describe them, or at least some of the founding fathers of Zionist socialism, as quasi-religious social anarchists.

One of them, Aharon David Gordon, wrote that the two most satisfying human experiences are creation and responsibility, regardless of on how small or big a scale. A human being who is deprived of these satisfactions will become a monster. The Zionist socialists were very sceptical about any romantic notions that all human beings are innately good. Instead they warned that the suppressed and exploited people of the world do not simply yearn to be free but

yearn also to become the suppressors and the exploiters. Admittedly, the concept of social realism has been contaminated by the Soviet Union. Were this not the case, however, then I would say that these early Zionist socialists were realistic socialists. They have a special place in my heart even though I know that their vision is, at the moment, such a far-off dream.

Israel today is an incomplete democracy, like any democracy faced with an obvious enemy, like the British or the Americans during the Second World War. And in some respects, Israel is more an anarchic state than a democracy. It's a country in which every individual wishes not only to change or influence the country, but also to rule it him- or herself. It is a nation of four million prime ministers and each of its four million people is a self-appointed Messiah or prophet. Each individual knows best. Politics in the west usually go hand in hand with the standard of living, with the price of beer. Here in Israel, politics is a matter of life and death. It's not something that happens somewhere on the distant horizon and that perhaps might have a moderate impact on our lives. Here, one bad decision we make could leave us dead. Not poor – dead. This is why our people are so politicized, so emotional and so involved.

Israel is a deeply democratic country because nobody accepts orders and nobody obeys automatically. But there are many holes in this democracy. Human rights are not what they should be. And when I talk of democracy in Israel, I'm not including the Occupied Territories: they are not part of Israel. To put it legalistically, they are under a military administration, and there is no such thing as a democratic military administration. In the West Bank or in Gaza there is not even the façade of democracy.

I am not Israel's Solzhenitsyn. I've never run into difficulty for having spoken my mind, although people have criticized me heavily and even sent threatening letters. There is no censorship and no government pressure on me to change my views.

It's not the army which shapes the nation, but rather the nation which shapes the army. Let me tell you a story. In June 1967 I was called up as a Reservist, and on the night before the Six Day War began, I was sitting beside the campfire with my comrades, all Reservists of different ages, and we talked about the imminent battle. At one point, the General emerged from the darkness and we fell silent. He began to tell us how he envisaged the battle. After some four sentences, he was interrupted by a plump, middle-aged corporal with glasses. Very politely, he said 'Excuse me, General, but have you read Tolstoy's *War and Peace*?' The General replied: 'What do you mean? Of course I've read it.' 'Are you aware that you're about to make the same mistake which, according to Tolstoy, the Russians made in the Battle of Borodino?' asked the Corporal. Within seconds, the whole group had entered a heated and noisy debate about Tolstoy, *War and Peace*, history, strategy and ethics. It turned out that the Corporal was a professor of Russian literature in Tel Aviv, while the General had a degree in philosophy from the University of Jerusalem. This is what I meant earlier when I said that it's the nation and its sense of anarchy which forms the army. Even today, this army frequently operates like a youth movement, dependent far more on argument and debate than on carrying out orders.

The Jews from ninety-six different countries of origin, would not have come here had they not shared a common literary, liturgical and cultural tradition with other Jews. Books are what have brought them here. Oppression might just as easily have forced them to take refuge in other countries, so why was it so natural for the Ethiopians to make their home in Israel? One need spend only a couple of minutes on any street here to discover that there is no such thing as a Jewish race. Jews are not an ethnic group and the only unifying force is in their heads. What does a German Jewish intellectual who settled here in the thirties have in common with an Ethiopian Jewish villager? Certainly not a preference for Bach, Goethe or interior design.

But both will have read and studied certain books, and they will both have been persecuted for being Jewish.

Modern Hebrew is currently evolving in the way that English did under Elizabeth I. Language is like molten lava, by which I mean that a writer or a poet can take huge liberties, inventing new words and forms. When I say that Hebrew is like Elizabethan English, I am not saying of course, that every writer is a new Shakespeare. At the moment, we certainly don't have more than half a dozen Shakespeares in Tel Aviv. But there is a very great temptation to re-shape the language, to take liberties with it. It's a great responsibility. Like any other language, Hebrew has a certain integrity which I'm keen to preserve and protect from modernization. For example, in Hebrew, the verb usually sits at the beginning of a sentence. This reflects a form of cognitive hierarchy. What's more important? Ever since the Bible, actions have taken priority: before we discuss where, why, to what end and to whom you have done something, let's first establish *what* you actually did. Languages reflect in a very profound way a certain cultural ethos, a system of values. I believe that the Hebraic value system is a good one and I'd like to preserve it. This system is under threat not only of modernization and from foreign languages. Hebrew is like a person with loose morals: it has slept around and been influenced by Aramaic, Arabic, Russian, German, Yiddish, English, Polish and whatnot. And all these influences have the effect of giving it enormous flexibility. One can put the verb almost anywhere in the statement and it would remain good, correct Hebrew, though it could suggest the linguistic background of the speaker. I often write such sentences, in dialogues, which removes the necessity of stating explicitly that a particular person comes from, say, Russia or the Middle East. When I write dialogue, I'm just a bystander and I always try to be a truthful bystander. But when it comes to a description or a philosophical or narrative passage, then I feel responsible for using and preserving the integrity of the Hebrew

language because of the values which I believe are inherent in her deeper structure. I often end up feeling like a kind of Don Quixote trying to defend something which no longer exists.

The verb is only one example among many. In Hebrew there is no verb for 'to have'. If I wanted to say that I have a wife or a packet of cigarettes I would have to say, quite literally, 'there is a wife with me', or 'there is a packet of cigarettes with me'. This might reflect a rather archaic or nomadic attitude. Someone or something is with you today but tomorrow they may be with someone else. Nothing really belongs to you. You cannot be an owner. This too is beginning to change under the influence of foreign languages. And this structure is also something I would like to preserve. I'm not a traditionalist. I'm not rejecting slang, I'm not against the introduction of new words or of giving new meanings to old words; I've even invented some of my own. When I need a word which doesn't exist, I can create one by adding a prefix or a suffix to a biblical word. Once a taxi-driver, someone who had no idea who I was, used a word I had invented in a conversation with me. That is the nearest to immortality anyone is ever likely to get. My books might be forgotten tomorrow, but this word will quite possibly survive for as long as the language itself does.

Every new wave of immigrants brings its own literary tradition with its own values. If you went to a certain literary café in Tel Aviv, until a few years ago, you would have come across the John Donne, the Lord Byron and the Allen Ginsberg of Hebrew literature all sitting at a table arguing with each other. All the literary traditions which have emerged out of Europe over many centuries have appeared here in just a few decades: Romanticism, Classicism, Social Realism and Surrealism. Franz Kakfa is a contemporary of Goethe here. But I would say that the influence of Russian literature has been the most significant, perhaps because the Russian immigrants were here first. I would therefore define my roots as being Hebrew and Russian.

Although I can only read Russian literature in translation, I was influenced by my family and read the Russians first, becoming familiar with Western literature only later on. There are people only ten or fifteen years younger than me whose chief influence has been English or American.

I sometimes have to leave my country in order to gain some distance from the politics, the language and the literary scene. But I could never stay away for longer than a year, because I start to lose touch with the language. I usually go to England or America. It has to be another country, another light, yes, preferably another climate. I love going north, partly because that's where my roots lie. I grew up with an almost mythological idea of Europe, a Europe which my parents both loved and despised. Every time I head northwards, and that could mean either Boston, Scandinavia or England, I have a strange feeling of *déja-vu*, that I've already been to these places. But I also experience a feeling of alienation, anger, sometimes even fear and a terrible sadness.

My grandfather was one of the early Zionists in Odessa. He was a Zionist before Herzl, and he was also a poet, a bad, sentimental poet who wrote poems about a Zion he had never seen and about the Hebrew language which he couldn't speak. He spoke in his mother tongues, Russian and Yiddish. When Russia became impossible following the Revolution, my grandfather, who was middle-class bourgeois, took his family and fled to Vilnius, at that time part of Poland. They lived there for fourteen years until anti-Semitism made life impossible there too. But even then it didn't occur to my grandfather to go to Zion because of his beliefs, since the living conditions there were too primitive, too Middle Eastern for him; he was a European. So in 1931 he applied for a US passport and the Americans said no. He applied for British citizenship and they said no, they had enough Jews. The French also said no. He was even crazy enough to apply for German citizenship in 1931. And I'm extremely grateful to the authorities of the Weimar Republic

for turning him down since I wouldn't otherwise be here today.

So the family finally decided with great sadness to go to Jerusalem, which in my grandfather's poetry was described as paradise on Earth, as a heavenly city. In reality, it was a very difficult place for him. The heat, the Middle-Eastern atmosphere, the provincialism, the vibrancy, the poverty, the isolation, the lack of a concert hall or a good opera or a good bookshop nearby, all made his life very hard indeed. The lack of *Culture*, or what he as a European would define as Culture. When he came to Jerusalem, he gave up his poetry. He became a businessman, importing last year's fashions from Vienna for the Middle-Eastern ladies of Jerusalem. That went well for a while, but after a few years, a Jew came on the scene who was cleverer than my grandfather and who imported last year's fashions from Paris instead. My grandfather was ruined and he took up poetry again. And once again, sentimental, sweet, Russian, patriotic poems about a Jerusalem where the streets were paved with gold, where God was everywhere and angels gathered on street corners. I was a small boy then and I asked my grandfather: 'Why do you write in Russian? Can't you speak Hebrew? You write love poems for the Hebrew language in Russian!' To which he replied, 'Listen, boy; I laugh, cry and dream in Russian and therefore I also write in Russian.' That made sense. 'But what's all that rubbish about angels and gold?' I continued. 'You've lived here long enough now to know what the real Jerusalem is like.' The moment I said 'the real Jerusalem', my grandfather went very red and exploded. 'What the devil would you know about the real Jerusalem? The real Jerusalem is the one in my poems!' And he was undoubtedly right. This story seems to illustrate the contradiction affecting Jerusalem as well as Europe.

My father did a PhD in Comparative Literature at the University in Vilnius and he came with his parents to Jerusalem intent on an academic career, hoping to become a university professor at the newly founded Hebrew University

in Jerusalem. He never did, because at the time there were more Professors of Comparative Literature in Jerusalem than there were students. There were several professors from the best universities in Germany specializing in this subject; my father only had a degree from the University of Vilnius, and so he became a librarian for the rest of his life. Of course, he wrote a string of books on Comparative Literature.

My parents used to say to me when I was a small boy: one day, not in our lifetimes, this Jerusalem will perhaps became a real city. And it took me twenty-five years to discover that by 'real city' they meant a city as there are in Europe. Their love-hate relationship with that continent is something I share and it influences everything I write: the feeling of having a home which isn't really a home, of another place which is wonderful but also terrible and dangerous, the feeling that Europe rejected my grandparents, my father and my mother. I feel a mixture of fascination and outrage towards Christian Europe, a fascination for the North with its large forests, cathedrals, and rivers with their bridges. And yet, as you can see, in the end I prefer to live here in the middle of the desert amongst other Jews, and this is my home. But here in Arad I do take the trouble to cultivate my little garden, so that I can have a micro-Europe in the middle of the desert.

My books are often seen as political statements, but they're not. If I want to state something very directly, for example that my government should go to the devil, then I'll write an article or go to a meeting or go on television and say, 'Dear government, go to the devil.' Not that the government then would, but I'll say it anyway. It's not worth writing a whole novel about the relatively simple question of what the government should do or what the solution to the Palestine-Israel question is. I would do this if I lived in a dictatorship and had to take refuge in allegory. But I don't have to do that here. If I want to make a political statement, then I'll write one. When the question is less simple – when

within me I hear several points of view – then, perhaps, I write a novel.

I've always been attracted to writing about unhappy characters, those misunderstood, discontented and unsuccessful individuals. Perhaps because happiness is relatively banal. Perhaps because it's banal to report on a bridge which has been planned and then successfully built. If the bridge exists, there isn't a story to tell. It has always been human suffering, disappointment, failure, loneliness and disillusionment which awaken the storyteller in me. I concentrate on the the morning-after syndrome, whether it's to do with marriage or an attempt to change the world.

Compared to the original idea, the kibbutz has of course failed. Compared to the original idea, Israel too has failed, because in our dreams we wanted to create something more perfect than perfection itself, something divine, where the streets are paved with gold and the angels hang around on street corners. But if one looks at the real world, it really is a story of success. The only way to keep a dream intact is never to try to make it a reality. Every fulfilment of a dream is a flawed fulfilment, whether it's the transformation of a passionate love into a prosaic marriage, rearing children or writing books. One has a *magnum opus* in one's head which one envisages being the ultimate truth or the absolute pinnacle of beauty, but one ends up writing what one can. The best that you can write will always be a long way from what you really wanted to write. Of course, there is in my novels a conflict between Messianic dreams, which are 'larger than life', and the petty, prosaic, tedious, grey reality of everyday life. But it's precisely this which fascinates me.

It's true to say that in my novels, love, ambition, and all other dreams are shattered. My characters never have small, modest, attainable dreams; they all have gloriously ambitious dreams, they all believe in something which I personally do not believe in – they believe in deliverance, in the possibility of being born again, of turning over a new leaf. Some of them believe in eternal, constant love, some

in everlasting happiness, where you simply arrive, lean back and enjoy your happiness for eternity. And it's precisely because these people hold beliefs I cannot share that they always have an unhappy end.

I've always believed that optimists must be very unhappy people, whereas pessimists have a chance of being, if not happy, then at least contented. The optimist gets up early in the morning expecting to find his slippers by the bed. But they're not there and he's disappointed. Then he cuts himself shaving and he's annoyed. He wants to make some coffee but there isn't any, or the electricity is suddenly cut off. The pessimist, however, never expects to find his slippers by the bed but if he does find them there then he's very pleased. He doesn't cut himself shaving and this, again, pleases him. He wants to make some coffee and he finds some and everything's all right with the world.

I know death at first hand. I became acquainted with it first as a small boy in Jerusalem, then on the battlefield. I saw death, ruined lives, loss and misery. I grew up amongst refugees forced to leave everything behind. In consequence, when I go out into the desert – as I do every morning – and I see the light and the stone, I feel an almost religious desire to say 'thank you' to someone. I don't know exactly whom I am thanking, it's just a way of saying that I don't take anything for granted. In contrast to my characters, I never take anything for granted, neither the coffee I've just drunk nor the daylight; the result is that I'm often nicely surprised. It's this perspective which allows me to step into the shoes of very disillusioned and unhappy people. If I personally was terribly disillusioned and unhappy, I wouldn't be able to write, just scream. Or beg for mercy. Or waste my life feeling sorry for myself.

So every morning, after I go out into the desert, and then drink my coffee and read the paper, I go downstairs and work like any employee or factory worker. I sit down for six or seven hours and work, sometimes without getting anywhere at all. When I used to work on a kibbutz, I had

terrible feelings of guilt about my unproductivity. *It's noon and everyone's coming back from the fields where they've been ploughing, milking the cows or picking apples, and they've all earned their lunch. And here I am, with ink-stained fingers, sitting in the same dining-room and nobody except me knows that for the entire morning I've only managed to write one and a half lines and cross out six lines from yesterday.* I used to be ashamed to eat lunch with these hard-working people.

And so, perhaps as a form of self-defence, I developed the mentality of the shopkeeper. It's my job to open my shop every morning at eight and wait for customers. If I've had customers, then it's been a great day. If not, then at least I've done my job by being there and waiting. So I always make myself do six or seven hours a day in my study. Either I write or I reflect. I wait for customers.

My books are not just about failure. They're also about a sort of reconciliation. *Elsewhere, Perhaps*, for example, concludes with a kind of re-ordering of a family. People, supposed to be deadly enemies, the child who's not strictly speaking the father's child, the family which hasn't been properly reunited, they all understand that even if their lives are a desert island, they are nevertheless forced upon each other, and that everything that they can have will come neither from God nor from an ideology but from each other. Nor would I describe *My Michael* as a tragedy. What is it that Hannah in *My Michael* wants so badly? She wanted an academic for a husband, she got one. She wanted a home, she got one. She wanted a child, she had one. Ah, but she wanted to levitate into the blue distance. In this respect I'm a complete romantic. I believe that people are born to play with fire, and we all play with fire and get burnt. Then we come back and try to heal our wounds and then we venture out again in order to burn ourselves all over again. It's this tragic dilemma between fire and ashes. The fire is more than we can bear – it's too hot, too scorching, it's wonderful but it burns us. And ashes are ashes –

boring, grey, monotonous, enough to drive you to despair. I lead some of my characters to the discovery that although we can't live with either fire or ashes, we can long painfully for the fire from the depths of the ashes. And likewise strive for the ashes from out of the fire. We want two simple things: we want peace and excitement. Only we can't have both. The only place where we can find both at the same time is in literature. This is where we find excitement enveloped by peace.

So you read in *My Michael*, about this poor woman Hannah who appears to have everything she wants. And what she doesn't have now, she'll get in the future. She wants a bigger home, and she'll have it. She wants her husband to become a university professor and he's bound to do so. She wants her son to be an achiever, and he will be. And despite this she's unhappy because death is getting the better of her every day. She dies bit by bit, day after day. The novel begins 'I don't want to die'. And she knows that the only alternative to death is this spectacular, hot burning: the Arab twins, the princess of Gdansk, the Red Indians, the submarines. All this romantic fire which she finally learns about would actually burn her to death if she ever really experimented with it. I have also pondered on this myself: why doesn't she take a lover – after all, she is a beautiful woman. But then she's read *Madame Bovary* and *Anna Karenina* and she knows that this isn't the answer. So what is the answer? Dreams: not simply either to realize or to forget them, but to dream on.

Writing about Chekhov, Vladimir Nabokov once said that those Chekhovian characters – the doctors or teachers in a provincial town or the intellectual landowners – they always have a great deal of sympathy with the poor starving people of Africa, with the coolies of China and the moujiks of Russia, but much less sympathy with their immediate surroundings, the poor wives whom they sometimes treat tyrannically, the children they sometimes don't even notice. Such a character is constantly stumbling around, says Nabokov,

but he stumbles because his eyes are always fixed on the stars.

Michael in *My Michael* is a good person, well-meaning, serious, hard-working, devoted, sympathetic, gentle. Only he is ash. His marriage to Hannah is a marriage of ash. He has no understanding of fire. The only way to overcome our own limitations, to realize that there are things we cannot do or achieve – or that we can do them, but the price is too high – is to recognize that we must find a compromise between ashes and fire. That we must have an awareness of both. Both are parts of you. And you must alternate between dreams and making a salad, between fantasizing and earning a living, between a desire to change the world and switching on the vacuum cleaner.

I'll tell you another story, told by Schopenhauer, I think. There was once a group of porcupines. They were freezing because it was very cold. As they were freezing, they tried to huddle up together. But as soon as they got near to one another, they caused each other tremendous pain. So they moved apart. But then they began to shiver again. So they got closer again and wounded each other again. This is the rhythm of life, this is what we do all the time. We can never be close enough and never be far enough apart. There is no leitmotif in my books, no 'do this, and you will be happy'. But I do like my readers to be able to smile about it all at the end. To be able to say, 'Yes, this is the comedy of humankind and I accept it, difficult as it may be.' Because it is painful, it is tragic, indeed very disappointing; yes, it drives you insane, but it is also comical.

One of my characters is, in some ways, closer to me than any others I've ever written about: the second kibbutz secretary, Srulik, in *A Perfect Peace*. In some respects, he is my mouthpiece. He wants to protect people from pain or at least to teach them how to accept and live with pain. How to avoid fanaticism. How to realize that everything is very relative. But one can only realize this if one changes one's perspective. I use the musical term 'polyphony' to

illustrate the fact that I've always tried to tell stories from several points of view.

I am no Hermann Hesse. Not at all. I have no recipes. I have no mantra. I have no map to draw with its road to happiness. But I have some ideas as to how we could be partly reconciled with each other and with our lives. How we can reconcile our dangerous longing for fire with the fear of the ashes. How we can both fly and keep our feet firmly on the ground. For me, this is an aesthetic reconciliation. We realize it through our dreams when we understand that though we can gaze and marvel at the stars in the sky, we can never touch them. But the fact that I can't touch them doesn't mean that I should never gaze at them. There are those people who say 'OK, I can't touch the stars, so I don't want anything more to do with them'. Gaze at the stars! You may never reach them, but don't let them out of your sight.

Interview, *Frankfurter Allgemeine Zeitung*, 3 May 1990
(*Translated by Jenny Chapman*)

Peace and Love and Compromise

THE PROPHET ISAIAH says: 'The wolf and the lamb shall feed together, and the lion shall eat straw like the bullock; and dust shall be the serpent's meat. They shall not hurt nor destroy in all my holy mountain, saith the Lord.' (Isaiah 65, 25)

Aside from this celestial peace, the Bible also deals with temporal, prosaic peace: 'And Abraham said to Lot [his nephew]: Let there be no conflict between me and you or between my herdsmen and your herdsmen, for we *are* brothers. Behold, the whole land is before you, please part from me. If you go left I will turn right, and if you turn right I will go left.' (Genesis 13, 8–9)

And this, I think, is a model of pragmatic peace in an imperfect world: precisely in order for people to remain on brotherly terms with each other, it is sometimes necessary to define their respective places. While aspiring to a loving union, we must nevertheless work within the boundaries of our human limitations.

One hundred and forty four years ago, more than five hundred people assembled in this church to create a democratic Germany. Had they succeeded, not only might the destiny of Germany and of Europe have been different, the destiny of my people and of my own family would have been different.

In the early nineteen-thirties, my family left Eastern Europe for Jerusalem, carrying with them a wound that never healed: they had regarded themselves as Europeans

65

while most of Europe regarded them as unwanted cosmo-
politans. They used to speak Russian and Polish with each
other, read German and English for culture, dreamed in
Yiddish, but me – they taught only Hebrew. Perhaps they
feared that if I knew European languages I might be seduced
by the deadly charms of Europe, from where my parents
were virtually kicked out through anti-Semitism and per-
secution. And yet, throughout my childhood, my parents
used to say to me, with pain and longing in their voices,
that one day our Jerusalem will become a 'real city'. For
them it meant a city with a river, with a cathedral in the
middle, and with forests round about. They ached for
Europe as much as they feared it. Now I know that such a
mixture of emotions is called unrequited love. In the twen-
ties and in the thirties, while my parents regarded themselves
as Europeans, almost everyone else in Europe was pan-
Germanic or pan-Slavic or a Bulgarian patriot. The Euro-
peans in Europe at that time were mostly Jews like my
family.

The creation of modern Israel is, among other things, an
outcome of the sad realization in the hearts of many Jews,
including my family, that even though in some times and in
some places there existed a deep and creative relationship
between guest and host, it was time to return home and to
rebuild it. The original hope was to build this home on the
foundations of peace and justice. The mass-murder of the
European Jews, the bloody conflict with the Arabs, and
the tragic clash with the Palestinians, have somewhat frus-
trated the idealistic dreams of the founders of Israel. A fair
and comprehensive peace will provide a chance to start over.

The reason I have conjured up these ghosts is that my
literary work and my peace activity are both inspired by
this past. And yet I believe that the past should have no
dominion. I reject all forms of tyranny of the past.

I also wish to convey to you the deep sense of ambivalence
I feel here today: a Jew in a church, an Israeli in Germany,
a peace activist who has twice gone to the battlefield because

of his conviction that the ultimate evil is not war itself but aggression.

Jews and Germans – what can we speak about? What *must* we discuss together? Well, one subject is our parents and grandparents. The other subject is the future. European civilization and Jewish civilization were married for a long time. The marriage was destroyed by an evil crime. But there were offspring from this union. There are European genes in our culture, and there are Jewish genes in your culture. These genes are not only ghosts – they contain a common ground for mutual creativity in the future. I won't use the term 'normalization'. What I am hoping for is intensification of the dialogue – including the pain, the horror, and the unrequited love. Because, to me, the way to avoid the dangers of history-poisoning or history-addiction is to regard history not as a heap of facts, a mountain of oppressive memories, but rather as a fertile field of enquiry and interpretation, thus using the past as building material for the future.

As I watch the attacks against refugees in Germany, I am well aware of the fact that Germany has probably received more of the recent refugees than has any other West-European country. Racists and fanatics exist elsewhere as well. But the question is, where are the very many people who should be out in the streets defending their own country from itself?

The fire in Sachsenhausen may have been meant to erase Germany's monstrous past. But it is not the past that burns in Sachsenhausen – the past, yours and ours, cannot burn. No, it is Germany present and Germany future which is in danger of catching fire.

This is not merely a question of Germany's duty to protect new immigrants and to watch over Jewish memorial sites – it is rather the urgent challenge facing the Germans to defend themselves now, against violent racism and against indifference.

How can we benefit from the past? What can Auschwitz

still do for the living, apart from injecting horror, grief, and silence? Perhaps, among other things, it can bring the urgent realization that evil exists. Evil exists not just in the way accidents exist; not just as an impersonal, faceless social or bureaucratic phenomenon. Not just as a stuffed dinosaur in a museum. Evil is an ever-present option, around and inside ourselves. The horrors of prejudice and cruelty are not simply a result of the perpetual clash between the sweet and simple person-in-the-street and the monstrous political establishment. The sweet and simple person-in-the-street is often neither sweet nor simple. Rather, there is a constant clash between relatively decent societies and bloody ones. To be more precise, we have to worry about the frequent cowardice of relatively decent individuals and societies whenever they have to confront the ruthless and oppressive ones.

In short: Evil is not just 'out there' – it is lurking inside, sometimes cunningly disguised as devotion or idealism.

Now, how can one be humane, which means sceptical and capable of moral ambivalence, and at the same time try to combat evil? How can one stand against fanaticism without becoming a fanatic? How can one fight for a noble cause without becoming a fighter? How can one struggle against cruelty without catching it? How can one use history while avoiding the toxic effects of an overdose of history? A few years ago, in Vienna, I saw a street demonstration of a group of environmentalists, protesting against scientific experiments on guinea pigs. They carried placards with the image of Jesus surrounded by suffering guinea pigs. The slogan read: 'He loved them too.'

Maybe he did, but some of the protestors looked to me almost as if they might eventually be capable of shooting hostages in order to bring an end to the sufferings of the guinea pigs. This syndrome of fiery idealism, or of anti-fanatic fanaticism, is something to which well-meaning people should be alert, here, there, and everywhere. As a storyteller and as a political activist, I constantly remind

myself that telling good from evil is relatively easy. The real moral challenge is to distinguish between different shades of grey; to grade evil and to try to map it; to differentiate between bad and worse and worst.

For many years I have been devoted to the Israeli peace movement, even before Shalom Achshav ('Peace Now') was established in 1977. The peace movement in Israel is not a pacifist movement, nor is it a product of American and Western European sensibilities of the sixties. The West Bank and Gaza are not Vietnam and Afghanistan. Israel is not South Africa, and the Israeli-Arab conflict has very little in common with imperialist and colonial histories. The peace movement in Israel is, in my view, an expression of the humanistic sides of Zionism and of the universalistic aspects of Judaism.

Twice in my life, in 1967 and in 1973, I have been on the battlefield and seen the monstrous face of war. And still I maintain that you never extinguish aggression by giving in to it, and that there are only two things which justify fighting: life and freedom. I will fight again if anyone tries to take my life or the life of the next person. I will fight if anyone tries to turn me into a slave. But I will never fight for 'ancestral rights', or for extra space, or for resources, or for the deceitful notion of 'national interests'.

The conflict between Israel and Palestine is, I always insist, a tragic collision between right and right, between two very convincing claims. Such a tragedy can either be resolved by total destruction of one of the parties (or both of them), or else it can be resolved through a sad, painful, inconsistent compromise in which everyone gets only some of what they want, so that nobody is entirely happy but everyone stops dying and starts living. Palestine will have independence and security in part of the land; Israel will live in peace and security in another part of the land. There is a good chance eventually for gradual reconciliation, for a cessation of the arms race, for developing a common market, and for healing the wounds.

Our peace movement in Israel is *not* pro-Palestinian. There is an absolute need to make peace between Israelis and Palestinians, and consequently between Israel and the Arab countries – not for guilt and atonement but for life itself. We, the Israelis, are in Israel to stay. The Palestinians are in Palestine, and they will not go away. We have to become, at least, reasonable next-door neighbours.

Yet even as I advocate the partition of one small land between two nations, I am still convinced that this is no more than a measure born out of necessity. I regard nation states as a bad and insufficient system. I think that upon this crowded, poverty-stricken and decomposing planet of ours there should exist hundreds of civilizations, thousands of traditions, millions of regional and local communities – but no nation states. Now, especially when national self-determination has deteriorated into bloody disintegration in some parts of the world, threatening to turn each of us into an island, there ought to be an alternative vision. There ought to be ways of fulfilling various legitimate yearnings for identity and self-definition within a comprehensive commonwealth of all humankind. We ought to be building a polyphonic world, rather than a cacophony of separate, selfish nation states. Our human condition, our solitude on the face of a vulnerable planet, facing the cold cosmic silence, the unavoidable ironies of life, and the merciless presence of death, all of these should at long last evoke a sense of human solidarity, overruling the sound and fury of our differences. Flag-patriotism must give way to humanity-patriotism, earth-patriotism, patriotism of the forests, the water, the air, and the light: creative relations with creation itself.

What can a storyteller do about all of this beyond telling stories? Is it reasonable for a writer to hope to bring about a certain change of heart? I have only partial answers to these questions. Take old man Tolstoy, for example: he probably had more direct impact over his contemporaries than any novelist throughout history: millions read him, hundreds

of thousands regarded him as a prophet. And yet, just seven years after his spectacular, 'biblical' death, Russia was taken over not by Tolstoyans but by characters out of Dostoevsky's *The Possessed*. Ultimately, the Stavrogins destroyed the Tolstoyans, butchered Turgenev's protagonists, re-executed Dostoevsky himself. Barely a decade after Tolstoy's death, Tolstoyanism was pronounced a subversive idea in the land of the Soviets. So much for the actual impact of literature on politics and on the direction of history. I could have picked my examples from Germany just as easily as from Russia.

Now, having implied that history completely ignores literary visions, I shall take a deep breath and immediately proceed to contradict myself: let us note the fact that seventy years after Lenin's cataclysm, Russia is returning perhaps not to Tolstoy but, ironically, to a somewhat Chekhovian condition of melancholy and paralysis.

Coming from Israel, having grown up in Jerusalem, I am of course aware of the varied impact of the Bible on the creation of Israel and on some of its present torment. Sometimes it almost seems as if everything in Israel had sprung out of books. The founder of the Zionist movement, Theodor Herzl, published his book *Der Judenstaat* (literally 'The State of the Jews') in 1896 (the English translation was published in 1934 under the title *The Jewish State*) fifty years before Israel became a nation, alive and kicking (indeed sometimes kicking too hard). *Tel Aviv* (the title in Hebrew of Herzl's *Altneuland*, 'Old-New Country'), a volume of futuristic narrative, was published in 1902, ten years before the very first house was built in that city. The kibbutz itself is an uneasy liaison between certain Jewish traditions and pre-revolutionary socialist texts.

Having said that literature has no influence and then that it has, what am I really saying? In a nutshell, I do believe that sometimes a book can change the lives of many people – but not necessarily in the way the author intended. And even this almost never happens overnight. Rather it happens

after many years, often through grave distortion and simpli-
fication. Frequently we discover that evil books and hate-
filled books travel much faster than good and subtle ones.

Some people may imagine that in the land of the prophets
and within the tradition of the prophets, writers and poets
assume a prophetic role. In some Western traditions, writers
are regarded primarily as fine and subtle entertainers. How-
ever, as I have often pointed out, in the Jewish tradition, or
should I say in the Judaeo-Slavic tradition, people expect
them to act as substitutes for the prophets. Some are indeed
tempted to do so from time to time. Yet let us not forget
that even the prophets, in their time, were not particularly
successful in changing the minds of their rulers or the hearts
of the people. It would therefore be utterly romantic to
expect present-day writers and poets to be more influential
than the prophets were in their day.

But forget the prophecy. Is there anything, anything at
all, that writers know better than taxi-drivers, or computer
programmers or even politicians? What, if anything, should
support the widespread expectation that literature can pro-
vide guidance and that writers can serve as the conscience
of society?

Well, one thing is that which writers may have in common
with secret agents: when you write a story or a novel, you
are putting yourself into other people's shoes, if not inside
their skin. You constantly imagine that you are him or her.
You give voice to a number of conflicting and contradicting
points of view with an equal degree of empathy, of passion,
and, sometimes, of compassion. This may help you to shar-
pen the emotional and the intellectual capacity to see the
validity of various, mutually exclusive points of view about
the same issue.

The other 'qualification' is the intimate relationship with
language: a person who spends half of his life choosing
between different adverbs and adjectives, examining nouns
and verbs, tormenting himself over punctuation – such a
person may also be well equipped to sense the early signs

of corruption of language. As I have remarked elsewhere tainted language often heralds the worst atrocities. Wherever particular groups of human beings are called 'negative elements' or 'parasites' or 'undesirable aliens', for example, sooner or later they will be treated as less than human.

So: writers are equipped to serve as the smoke-detectors of language, and perhaps as the fire brigade of language. They may be the first to smell a dehumanizing vocabulary – and hence their moral obligation to scream 'Fire!' whenever they smell it. (Whether anyone will pay attention is a different question: Let's remember Kierkegaard's tale about the actor who shouted 'Fire!' whereupon the entire audience clapped their hands and shouted 'Bravo!')

Whether moving mountains or only shifting semi-colons, writers are primarily experts in choosing words, arranging and rearranging them over and over again. I think that the selection and arrangement of words is, in a small way, a moral choice. In preferring a particular verb, in avoiding clichés and idioms, or in using them upside-down, you make a decision which may have at least a microscopic ethical consequence. Words can kill: this we know only too well. But words can, in small measure, also heal sometimes.

Here is my dilemma: what should a man of words do if he happens to live next door to injustice, to prejudice and to violence? What should this man do when all he has is a pen, a voice, and sometimes a relatively attentive audience? What do you do when basic decency demands that you try to combat political evil, rather than just observe, describe, and decipher it? How do you go about making what seems to be an impossible choice between civic decency and artistic integrity?

Is it immoral for a writer to turn his pen into a political weapon, or is it immoral for him to beat his pen into a polemic sword?

I do not have a universally valid answer. All I can share with you is my own inconsistent compromise. I have been involved in politics, without giving myself over entirely to

the crude craft of producing manifestos, coarse sermons, or simplistic political allegories.

I have said on several occasions that whenever I find that I agree with myself one hundred per cent, I don't write a story – I write an angry article telling my government what to do, sometimes telling it where to go (not that it listens). But if I find more than just one argument in me, more than just one voice, it sometimes happens that the different voices develop into characters then I know that I am pregnant with a story. I write stories precisely when I can step into several antagonistic claims, diverse moral stances, conflicting emotional positions. There is an old Hasidic tale about a rabbi who is called upon to judge two conflicting claims to the same goat. He decrees that both claimants are right. Later, at home, his wife says that is impossible: how can both be right when they claim the same goat? The rabbi reflects for a moment and says, 'You know, dear wife, you are right too.' . . .

Well, sometimes I am that rabbi.

Our readers in Israel do not always draw the line between narrative and essay. They often read a simplistic political message into what was meant to be a polyphonic story. Readers outside of Israel also tend to read our literature as political allegory – but this is often the fate of novels which come out of troubled parts of the world. You think you have written a piece of chamber music, a tale of one family, but your readers and critics say, 'Aha! Surely the mother represents the old values; the father is the government; and the daughter must be the symbol of the shattered economy.'

At the end of the day – and I mean, quite literally, at the end of almost every day, full of sound and fury – there comes the time for a still, small voice. This is the time when I sometimes reflect, not on this or that useful political argument, not even about the right adverb for a stubborn sentence in a story, but – for example – about Jesus' famous words. 'Forgive them, for they know not what they do!' In fact, I think he was wrong, not about forgiveness, but about

the knowledge. I think we all know very well what we do. Deep down we know. We have all eaten from the fruit of the tree whose full name is 'The Tree of Knowledge of Good and Evil'. I am convinced that every human being knows very well what pain is – we all experience pain – and therefore, whenever a human being inflicts pain, or worse, on another human being, he knows what he is doing.

This is my simple credo. And since we know what we are doing whenever we inflict pain on others, we are also responsible for what we are doing. We may still forgive, we may still be forgiven, but *not* on the grounds of childish innocence or of moral infantility.

What am I doing now, coming all the way from Jerusalem to a church in Germany to pick a fight with Jesus? Well, we Jews have never managed to keep our differences to ourselves.

And sometimes, at the end of the day, I reflect upon Immanuel Kant's observation on 'the crooked timber of humanity, from which you can never carve anything entirely straight'. Again and again I wonder why, for thousands of years, so many redeemers, ideologues, world-reformers have been endlessly trying to do just that, often using saws and axes, trying to carve something straight and shapely from the crooked timber of humanity. Instead of trying vainly to change each other, why don't we simply remind ourselves from time to time that no one should add more pain to the anguish already designated for us in life and by death? That deep down below, all our secrets *are* the same?

Ultimately, as the evening breeze begins to blow over the darkening hills of the desert, you pick up your pen and start writing again, working like an old-fashioned watchmaker, with a magnifying glass in your eye and a pair of tweezers in your fingers; holding and inspecting an adjective against the light, changing a faulty adverb, tightening a loose verb, reshaping a worn-out idiom. This is the time when what you are feeling inside you is far from political righteousness. It is rather a strange blend of rage and compassion; of

75

intimacy with your characters mingled with utter detachment. Like icy fire. And you write. You write, not as someone struggling for peace, but more like someone who begets peace and feels eager to share it with the readers; writing with a simple ethical imperative: Try to understand everything. Forgive some. And forget nothing.

Write about what? The Israeli poet, Natan Zach, has given me a good definition of my subject matter:

> This is a poem about people
> About what they think
> And about what they want
> And about what they think they want.
> Few other things in the world
> Deserve our attention . . .

And so I write about people and what they think and what they want and what they think they want. What else is out there? Well, there is also the primeval chorus: Death and desire, loneliness and lunacy, vanity, void, dream, and desolation. There are the gushing rivers and the silent mountains, and oceans and deserts. And there is, of course, language itself – the most dangerous of all musical instruments. Ultimately, there are those ancient, grumpy Siamese twins, Good and Evil, moving from life to books and back, never separated, never satisfied, always wagging their skeletal fingers at you, making you sometimes wish you were a musician instead. But no: you are confined to words, thus responsible for every misuse of words, at least within your own language.

The defence of language is my own way of promoting peace: a ceaseless struggle against the degradation of language, against the perpetuation of stereotypes, racism, and intolerance, against the celebration of violence. Time and again I have been appalled by the words which are used to promote even my own novels in civilized countries: 'powerful', 'smashing', 'overwhelming', 'explosive'.

I do not believe in the possibility of a perfect peace —
remember the 'crooked timber of humanity'. Rather, I work
for a sad, sober, imperfect compromise between individuals
and between communities, who are bound always to remain
divided and different but who are nevertheless capable of
working out an imperfect coexistence. The Psalmist says,
'Mercy and truth are met together; justice and peace have
touched.' (Psalm 85, 10–11) Yet the Talmud points out an
inherent tension between justice and peace, and offers a
more pragmatic concept: 'But where justice prevails, there
is no peace, and where peace prevails, there is no justice.
So where is justice that contains peace? Indeed it is in
partition.' (Sanhedrin 6, p.2)

Rabbi Nachman of Bratslav (1772–1810), one of the out-
standing leaders of the Hasidic movement, says: 'The essence
of making peace is in bringing together two opposites. Never
panic . . . when you see two parties who are totally antagon-
istic to each other . . . indeed it is the crux of the wholeness
of peace, to attempt to bring peace between two opposites.'
(Likutei Ha'Moharan, Part A)

All I can add to this is just the notion that only death is
perfect. Peace, like life itself, is not a burst of love or mysti-
cal communion between enemies but precisely a fair and
sensible compromise between opposites.

Acceptance speech, International Peace Prize of the German
Publishers' Association, Frankfurt, October 1992

Whose Holy Land?

Divided Israel in Palestine

UNDERNEATH THE ARGUMENT about the future of the Occupied Territories lurks a deep division whose origins go back before the wars and the occupations. It is a division over the character of the state of Israel, over the nature of Jewish existence at the present time, and over the meaning of the Jewish heritage; a division over the relationship between Jewish values and Western culture, which has its immediate roots in the Renaissance but whose roots go all the way back to the Bible and Ancient Greece. And deeper still there may well lurk a division over the very meaning and purpose of life.

Behind the question, 'What is one justified in dying for and what is it permissible to kill for?' there always stand two other questions: 'What are we living for?' and 'How should we be living?'

Some of these conflicts were concealed or repressed in the foundations of the Zionist edifice; their solution was postponed because almost all the parties involved wanted to prevent an explosion, to avoid a *Kulturkampf*, and in any case they wanted to wait for the majority of the Jewish people to arrive in Israel before taking any decision about the basic ground plan.

That is how it happened that the building sprang up without a plan, without a decision on the basic questions of who we are and how we came to be living here.

The Six Day War of 1967 and ensuing occupation could have precipitated a decision and brought us to the moment

78

of truth. If the goal of Zionism is to reconstruct the king-
dom of David and Solomon, then there is a clear answer to
the question of what to do with the territories we had
conquered. If the goal of Zionism is to set up an enlightened,
tolerant, humane and free society, then there follows an
equally clear answer to the question of what to do with the
conquered territories.

The question of purpose and meaning had become urgent
and concrete after the Six Day War. Only the Three Noes
adopted by the Arab heads of state at the Khartoum summit
– No peace with Israel, No recognition of Israel, and No
negotiations with Israel – enabled many of us to go on
disguising fundamental existential questions as practical or
tactical disagreements, such as what is and isn't 'realistic',
what 'the world' will or won't permit us to do, what to say
and what not to say in our propaganda (or 'information',
as we like to call it).

And then there came three events that confronted us, once
again, ineluctably with the true questions: Who are we?
What is our purpose? What are we living for and how are
we going to live here?

The first event was the peace with Egypt, which shattered
the common convention that we are locked into a 'bloody
circle' from which our fate allows us no way out. The other
two events are the Palestinian uprising in the Occupied
Territories and the historic about-turn in the declared aims
of the PLO.

For upward of twenty years they have repeatedly been
told by our leaders that the question of 'peace or territories'
is a hypothetical one, that there's nobody to talk to, nothing
to talk about. Now (at the end of 1989) there is someone to
talk to, there is something to talk about, and we can start
talking peace – yet we go on evading the issue because we
are afraid to face the question of who we really are and
what the purpose of Israel's existence is and what we are
supposed to be living for. The moment of truth has arrived
and we are floundering in lies.

Perhaps at this point I may offer a little parable. Let's imagine a father, a mother and a very sick child. The father, in our story is sincerely and profoundly convinced that the child should go straight to hospital and undergo major surgery; if not he will die. The mother believes with all her might that if the child has the operation he will die. Both parents have a battery of medical experts ready to supply learned opinions to support their position. What does one do in such a situation? Assuming that there is no judge, arbitrator or agreed authority who can decide between the conflicting positions of the father and the mother. What do they do?

They argue. They blame each other. They hold each other responsible for the impending calamity. They call each other lunatic, murderer, and so forth. But what do they do? How is such a tragic dispute resolved?

Now in this parable I am naturally talking about the most reasonable people in both camps. Not about the demagogues. In such a situation there is a real danger of wild or violent ideas occurring on one side or other. In order to save the child from death, the other parent must be neutralized. Denied the right to interfere or deprived of the possibility of interfering. Removed. Isolated. Institutionalized. Or perhaps worse, the child might have to be kidnapped.

It is a fact that hundreds of thousands of Israelis are convinced – *intellectually* and *emotionally* – that if Israel keeps hold of the Occupied Territories then it will cease to exist. Nothing less than that. While hundreds of thousands of other Israelis are convinced that if Israel pulls out it will cease to exist. Nothing less than that. Both sides are armed with precedents, expert opinions and indications that appear to them to be infallible. So, what does one do in such a situation?

First, even in such a tragic conflict as the one in my rather melodramatic story, it is worth stopping and checking whether there is anything that the two sides can agree on. A basis. A handle. The end of a thread. As in real life, both sides agree that the child is in grave danger. Both sides sense

an imminent catastrophe. Both share a sense of emergency. And indeed (it is sometimes worth pointing out the obvious) both sides love the child and want it to do well.

However, a split like this naturally involves all the previous tensions between the parents. It deepens and sharpens all sorts of fundamental conflicts, which are merely exacerbated or concentrated by the question of the 'operation'. Each side talks about saving the child – and means, in fact, a lot less than that – and a lot more as well.

For instance, it may well be that the child will not die even if he is not operated on, but that he will turn into a monster. Or, on the other hand, the child may survive the operation, but be changed by it into a creature which one parent can no longer stand.

To return from the parable to the real-life situation. Behind the question whether there will still be life after the partition of the land, or whether there will still be life for an Israel that continues to occupy, to oppress, to colonize, and which might eventually even expel large numbers of Arabs, peer out the old, repressed questions, the inherent contradictions which we have vainly been trying to evade: What sort of Israel will it be? What did we come here for? May life without a homeland not be preferable to this kind of horror?

Many of us see no sense and no place for ourselves in an Israel that resembles Iran, South Africa, Libya or Belfast. Yet for many other devoted Israelis a secular, 'permissive', democratic, hedonistic, pluralistic, modern Israel, which belongs to all its citizens and not only the Jewish ones, is a defective, despicable creature, embodying (in their view) the final decline of Judaism as they understand it.

It follows that the debate over continued occupation versus withdrawal from the Territories in the framework of a peace agreement conceals an unfathomable rift over the question of the meaning and purpose of life.

I have deliberately exaggerated all this out of a feeling that now may be the last chance to begin to make an effort

(no less an effort perhaps than that made by the Israeli left in the dialogue with the PLO) in an attempt to reach some kind of minimal dialogue between the undogmatic doveish left and the rational hawkish right – and perhaps also with national religious groups that do not hear heavenly voices every night. I am not talking about a consensus over the question of frontiers, but actually an attempt to reach some understanding on the question of how we are going to live here after we get peace.

Among those who maintain, *vis-à-vis* the Palestinians, a 'not an inch' position, there are several who are genuinely afraid that an Israel without Nablus and Hebron and with open peaceful borders will become materialistic, secular and hedonistic, 'a land of discotheques' (as they put it), which, to them, is almost as bad as total destruction. Just as many of us consider that an Israel that clings to Nablus and Ramallah would be at best a binational state, a second Lebanon, and at worst a racist slave-state, which for us would represent 'the end of it all'.

There may be some point in trying now, at the eleventh hour, to clarify whether it is possible to reach some sort of understanding between part of the left, at least, and part of the right, on what sort of *modus vivendi* the two groups can agree upon, at least for the present generation. In this way it may be possible to fashion a minimal consensus also on the questions of the Territories and peace. Without such a consensus – partial and provisional as it might be – there is no chance that Israel will voluntarily return territories in exchange for peace.

Admittedly, some people will shrug their shoulders and say, 'What difference does it make? If Israel is so torn by internal divisions that it will not voluntarily hand over territories in exchange for peace, a harsh slap of reality will in any case force Israel to pull out of the Territories: a further round of war, or an ultimatum from the super-powers, or both.'

But this sort of shrugging of shoulders is a sign not merely

of despair but of foolishness. An Israel driven out of the Territories by force, with its spittle dribbling into its beard and its eyes whirling in their sockets, is an Israel that has no future, because its spirit will have been broken and because the internal rift will not be healed but deepened by internal accusations of treachery and stabbing in the back. Worse still, an Israel broken, humiliated and crushed will inevitably whet the appetite of the wildest and most extreme elements in the Arab world and among the Palestinians.

Let me repeat and emphasize: without at least a partial, provisional, limited agreement between part of the left and part of the right, there is no chance that Israel will voluntarily return territories in exchange for peace.

Israel must come to a peace agreement and to the withdrawal that entails, of its own free will, out of a broad measure of national consensus, out of awareness and self-confidence, and even out of a measure of pride, making sacrifices for the sake of peace.

And as I have already said, such an agreement between the doves, or most of them, and sections of the nationalist and religious right, a partial, temporary agreement, needs to address itself first to the question of the image of Israel after a peace. Unless some at least of the fears of the right about the future appearance of Tel Aviv or Beersheba are allayed, that right will never agree to pull out of Nablus or Gaza. I see a mortal danger in the continued repression of the internal rift over the character of Israeli society and its camouflaging as a division over the location of the frontiers.

On the right and the left I see people seething with moral fury or trembling with dread at what each side regards as 'an impending moral collapse'. From tactical considerations, as it were, they prefer to disguise their moral distress with talk about 'realistic or unrealistic approaches' or about 'what is or isn't practical'. On the left and right, as well, many people really want to shout: 'I don't want to live like that, I can't live like that.' But they find it easier to explain themselves by saying instead, 'the security risk is a reason-

able one' or 'there is someone to talk to' or 'there is no one to talk to'.

Instead of saying openly: 'Here I have reached the limit of my moral integrity, beyond this point I cannot go,' people say, 'The superpowers won't let us' or alternatively, 'The outside world will get used to it and swallow it' or 'It'll lead to mass emigration' or 'It will actually encourage immigration', etcetera, etcetera.

An example: faced with the idea of the expulsion and banishment of the Arabs – what is lyingly called 'transfer' – decent, humane, liberal people can be heard to mumble, 'It's an impossible option because it'll lead to a terrible war', or 'because the civilized world won't tolerate it'. When we ought to be standing up and saying firmly and simply: 'Forget it. We won't let you drive out the Arabs – even if we have to split the country and the army. Even if we have to lie down in the path of the lorries. Even if we have to blow the bridges up. There won't be any mass expulsion, because we won't allow it to happen.'

What we ought to be doing therefore is to indicate, loud and clear, our moral red line without leaning on any big uncles from outside. The Israeli right has to learn that there are certain things it cannot do without bringing about the dismemberment of the state. Just as there is an obligation on all of us, and perhaps particularly on the doveish left, to explain over and over again to the Palestinians where our red lines are as far as they are concerned, and on what we, all of us – hawks and doves alike – will stand and fight them to the bitter end. Just in case any of them get the false and dangerous impression that part of the doveish left loves them and is ashamed of Israel's actions – to the point of self-negation.

Which leads me to the moral dimension of war and occupation. And I have deliberately chosen to say 'war and occupation' so as to dissociate myself from the simplistic and dangerous slogan 'Down with the occupation'. Hearing this slogan, one might imagine that Levi Eshkol's Israel of

1967 suddenly decided it was short of space, attacked its neighbours, occupied some territories, and now it's enough for Israel to get up and pull out of these territories for all of us to live happily ever after.

Of course 'occupation corrupts' (and how!), but occupation is a consequence of war, and war corrupts even without occupation. By the way, war corrupts on both sides, not only the winners and occupiers. I am not among those who are comfortable with the feeling that 'the Vietnam War rides again' and that all we have to do is pull out of our Vietnam and everything will come out right; or that ours is a case of good old-fashioned colonialism and all we need is a dose of de-colonization for everything to be fine; or that what we have here is a story of denial of civil rights, and that if we just grant academic freedom to the universities of Bir Zeit and al-Najah then Hebron can be integrated with Kiryat Gat by yellow buses, and it'll be all beer and skittles.

We are not talking about de-Vietnamization or de-colonization or granting equal civil rights to the Palestinians. The monstrous situation in the Territories is merely the rotten fruit of a 70-year-old war. The occupation itself was not the cause of the war but its consequence. And the solution is not integration, but separation through self-determination: two states for two peoples.

Up to a few months ago the Palestinian national movement rejected such a solution. Now the Palestinians say they are prepared to accept it, and it is Israel that refuses. One must not forget that since 1977 no Israeli government has offered peace in exchange for territory in the West Bank and the Gaza Strip, and since 1949 no Israeli government has offered peace between Israel and Palestine.

Is it permissible at all to speak of occupation and morality in the same breath? A good friend of mine told me a few days ago that my discussion of the present situation under the title, 'War, Occupation and Morality', reveals my hypocrisy, because where there is no morality there is no occu-

pation and where there is occupation there is no morality. Full stop. All the rest belongs, so she maintained, to the sanctimonious sludge of the 'shoot and weep' school.

This is a deceptively simple point of view: all war and all occupation is immoral, and that's that. Anyone who shoots has no right to weep, and anyone whose heart bleeds should simply throw away his gun and stop shooting. It is interesting to note how close this point of view comes to the standpoint of the tough wolves on the right, who proclaim that the concept of 'purity of arms' is totally hypocritical, because guns are meant for killing as many people as possible, without moral prevarication and, in a war, morality (like women and children) should stay at home.

I do not accept this black and white view. The moral impulse cannot exist in black and white, without being blinded and becoming a tool of propaganda and fanaticism. Even if we say that all occupation is immoral – even the occupation of fascist Japan by America – we still need to ask: how immoral? Is it possible to place on the same level, let us say, the occupation of part of France by the Germans and the occupation – a few years later – of part of Germany by the French forces? Are these two occupations equally bad – in terms of what caused each of them, in terms of the occupiers' objectives, in terms of the situation of the defeated population living under occupation?

It would seem that we are capable of distinguishing virtually instantaneously between good and evil. And it would seem that we all have an urge to put the evil in the pigeonhole marked evil and the good in the pigeonhole marked good. We feel warm and cosy with that. But generally speaking we are able – and consequently also obliged – to distinguish. To discriminate not only between good and evil but also between evil and evil. And reality very often confronts us with situations where we have to make a difficult choice between two evils.

I am not going to go into the eternal questions, whether the ability to distinguish between good and evil and between

86

different shades of evil is congenital or socially conditioned; whether the whole of morality is a system of agreements dependent on time and place and changing as society and government change, or whether good and evil exist in an absolute, unchanging sense, and all, or almost all, of us know them in our heart of hearts, if we have not completely taken leave of our senses, only we sometimes choose to ignore them or pretend that we do not know them, or try to be clever and say everything is relative and where is it written and who says and let's see and prove it.

I shall also pass over the fascinating question of the relationship between morality, law, and an order from your commanding officer. I shall content myself with stating that morality, law and military order are not just three names for the same thing, but three interrelated but different things. Once we have agreed on that point, we can take a few steps further. An illegal order is, as everyone knows, an order that conflicts with the law. If it contravenes the law in a clear and unmistakable way then it is an evidently illegal order and the Supreme Court of Israel, in the case of the Kafr Kassem massacre, ruled clearly that not only is it permissible to disobey such an order but it is one's duty to refuse to carry it out; and if you do obey such a clearly illegal command then you have to carry the responsibility for your obedience and you cannot hide behind the defence that 'I was only carrying out my orders'.

What should you do if you receive an order that is not illegal, but that you regard as immoral? What should you do if you receive an order that, while not in conflict with the law, is evidently immoral? What should you do if you receive an order that is immoral and illegal, but not evidently illegal?

Of course, it is easy to decide how to act if your platoon commander orders you to shoot your company commander, or the company commander orders a woman soldier to sleep with him, or the regimental commander orders you to hang the chief of staff, or the chief of staff orders you to attack

a plenary session of parliament with hand grenades, or the whole lot of them, including the minister of defence and the members of parliament, pass a law ordering you to kill your own parents.

All these are evidently immoral orders, as things stand they are also evidently illegal, and some of them are also evidently insane, and every normal persons knows – even without the precedent of the verdict in the Kafr Kassem affair or the Eichmann trial – that it is wrong to obey them. But what happens when the order is to beat up an unarmed man? To break demonstrators' arms? To punish a family whose nine-year-old child has thrown a stone? To destroy people's property?

Let's look at what I would consider an immoral and apparently, although perhaps not evidently, illegal order. What should you do when you are given an order which you know in your bones is immoral, which you imagine and believe is also illegal, but maybe not 'evidently' illegal, or not 'evidently' enough?

According to the dictionary definition, 'evident' means 'that can be seen; clear to the mind; obvious . . .' Now, is X entitled to refuse to carry out an order to impose a personal or collective punishment in a Palestinian refugee camp, because it is evident to him that no soldier or police-man or detective has the authority to impose punishment? And is Y, who has never learned that people may only be punished after due judicial process, and so does not know that an order to punish people is illegal, therefore obliged, unlike X, to carry out the same order, because in his case the element of 'evidently' is lacking?

And when the tribunal has to sit in judgement on X and Y, who stand accused of carrying out punishments in the Occupied Territories in obedience to the orders of their immediately superior officer, should the court acquit Y, who was not aware that the order he was obeying was an 'evidently' illegal one, and convict X, who was aware? Because what is 'evident' to X is not even a vague supposition to Y.

88

I know that, sadly, this is a theoretical exercise. In the majority of cases X and Y will do what they will do in the refugee camp, and the rest of us will hear nothing and see nothing. At best, an inspecting officer will be appointed to examine the details of the case, and a few months later – if anyone bothers to enquire what the upshot of the investigation was – we will be told that 'lessons were learned' or 'conclusions were drawn' or that 'the investigation is continuing'.

Of course, one could say this: there is a Geneva Convention, and the state law ought to stipulate that anyone who contravenes it is a criminal. What is more, every soldier should be ordered to memorize the relevant parts of the Convention. Then nobody could plead 'I didn't know what I was doing', and illegal acts would be not only illegal but evidently illegal.

But unfortunately the Geneva Convention only applies to situations of temporary, short-term occupation, not to situations in which the conqueror is clever enough to define himself simultaneously as conqueror and non-conqueror, to implement the letter but not the spirit of the Convention, to implement only the parts that suit him, and to claim in the same breath that the occupation is perfectly humane and legitimate, and that in fact it is not a case of occupation at all, but of liberation of the ancestral home.

International law recognizes the act of occupation and applies certain rules and restrictions to it. Only, in the case of the Israeli occupation of the Territories for the past 22 years, the conqueror has chosen – as a matter of convenience – which restrictions to ignore and which rules to implement, with much sanctimonious rolling of the eyeballs. And the inventor of such an abominable and ridiculous term as 'present absentees' (for Arabs who live in Israel but have no papers) will have no difficulty in formulating something like 'liberational occupation' or 'annexation of lands with autonomy for the inhabitants'.

What is to be done? Have we reached the ultimate cross-

roads, where every individual has to choose between obedi-
ence, including criminal obedience, and disobedience, which
really means nothing less than rebellion?

We have seen some changes of role which are almost
comical. Different sides in ancient debates have exchanged
positions and arguments, either on account of political senti-
ments or party loyalties. We have heard former 'dissidents'
thundering at those on the left who have had meetings with
the PLO that the law is above conscience, and what sort of
a scandal is this, for everybody to have his own private
foreign policy. We have heard the rebels of Sebastiya and
the objectors of Yamit shouting at the objectors of the
Lebanon war and the objectors to service in the Territories.
We have heard the objectors of the Lebanon war and service
in the Territories rebuking the objectors of Kiryat Arba, that
the law is supreme overall. Or, alternatively, that conscience
is supreme above the law. Or, alternatively, that the sanctity
of life is superior to conscience and law together. Or, alterna-
tively, that the sanctity of the land or the sanctity of the
Torah is superior to the sanctity of life, conscience and
the law. Or that morality overrides security, or that security
overrides the law, *ad absurdum, ad nauseam*, until the sub-
machine-guns override everything.

Even though it is wrong to mention in the same breath
the members of 'There is a Limit' (who consciously and
willingly accept their punishment for refusing to serve in
the Territories) and those on the extreme right who don't
give a damn for the law (who maintain that the whole law
is only there to be broken, and who believe they deserve to
be rewarded, not punished), one should never forget that
what the extreme right is demanding is a licence and legitim-
ation to kill, expel, crush, maltreat and deport until there
are no Arabs left here. Or until the Arabs are broken and
agree to accept from now on and for ever the status of
docile slaves in a Greater Israel, which will belong only to
those born of a Jewish mother or have converted to Judaism
according to the Orthodox law.

Whereas those who object to service in the Territories, according to the Kantian logic of their actions – that is to say, whatever I do, I wish and am prepared for it to be accepted as the general norm – would be delighted to see the IDF getting up at midnight tonight and pulling out of all the Occupied Territories, even without a peace, without security arrangements, without any Palestinian undertaking to be satisfied with the Territories, without an end to the state of war. Get up and pull out. And it is still not clear to me what their position would be if an *intifada* started up in those enclaves within the Green Line which have an Arab majority, such as Nazareth and Lower Galilee.

Let us return now to the root of the conflict, which all sides disguise with wrappings that seem better suited to marketing and the justification of their positions. The heart of the conflict is whether a people surrounded by enemies is entitled to do everything, including things that are defined as war crimes, so as to repel its enemies. Furthermore, is an enslaved people groaning under foreign occupation entitled to do everything, including things that are defined as war crimes, so as to liberate itself from the yoke of occupation?

Do despicable and criminal methods employed by your enemies give you, or do they not, the right to employ reprehensible and criminal methods in your own struggle? And again, in time of war, at a time when you are rebelling against those who have enslaved you or, conversely, you are struggling to put down a rebellion against you, at such a time should morality, like women and children, stay at home?

And yet again, is what Israel was permitted to do in 1948 – when the question was whether the Arabs would succeed in slaughtering the lot of us – also permitted now, when the question is whether when all is said and done we shall have four rooms or only two and a half?

The time has come for me to answer some of my own questions. Occupying territory means taking something from

somebody else by force. Occupation of territory means breaking the will of human beings, and imposing your will by force of arms on somebody else. So long as the will of this other person is to kill you or to impose himself on you by force, there will be a justification for occupation, just as a war whose purpose is self-defence is a just war. But from the moment the other person renounces his aim of annihilating you, you must enter into negotiations in order to study the extent of his sincerity and the kind of guarantees that he is offering you in return for the termination of the occupation. If you fail to enter into negotiations then the minimum justification for occupation has been removed.

It is not because of the *intifada* that the justification for the continuation of the Occupation has been destroyed, but because of the proclaimed change in the Palestinian position. And a government that continues the occupation is placing its soldiers and police and citizens in a position, in terms of morality and conscience, from which there is no way out.

Yitzhak Shamir expresses his sympathy for the suffering of our soldiers in the Territories and his understanding of the distress that they feel in this situation which the government has got them into. Forty-five years or so ago Natan Alterman wrote in his Seventh Column, in response to the claims of a British spokesman that His Majesty's troops were not to be envied for their thankless task in Palestine:

'No, Sir do not envy the good Labour soldier,'
quoth London. 'He's not just a fighting machine.'
Quite right, Sir, quite right – he is envied by no one,
And in general envy is almost obscene.
Yet I feel I should mention a hoary old proverb
That comes to my mind every now and again:
Here it is: 'Never envy the poor hard-pressed gov'ment
that says "Do not envy our brave fighting men".'
 What is more, there's a rider (here's balm for the gov'ment).
Concerning the people (for them it's no joke!):
'Whenever a gov'ment has nothing to envy
Then be certain there's nothing to envy its folk.'

The logic is ruthless; it's brought mighty empires
like Persia and Rome to decline and to fall:
It begins when you say 'Do not envy poor Tommy',
Then it spreads – and it rises –
 and grows thick and tall –
Till at last there is no one to envy at all.

When I was eight years old I used to throw stones at
British soldiers near the Schneller Barracks in Jerusalem,
and shout at them my total vocabulary in English ('British
go home!'). I am convinced that the only way out of this
situation is to make peace and to end the subjugation of a
population that longs for freedom. There is no hope in the
muddled efforts of Yitzhak Rabin to preserve the illusion of
a policing operation when it is nothing of the kind, when
we are actually confronting not lawbreakers and hooligans
but a nation fighting for its freedom. We must not follow
the brutal counsel of those who are trying to lead Israel
astray down the road that leads to mass murder, a road
from which there is no return.

The Israeli occupation of the West Bank and Gaza is
collapsing not because youngsters are throwing stones at us,
but because the foundations of the arguments on which the
Occupation rests have collapsed. Even while the Palestinians
were brandishing the banner of the annihilation of the Israeli
state, there was already a growing debate in Israel about
whether it is worth staying in Nablus and Gaza: is there
really no other way?

But once that banner of annihilation was officially folded
up and stowed away, at least in the pronouncements of the
leaders of Palestine, the question is no longer whether it is
worth it, but whether it is right.

And the answer is that it is wrong, and that immediate
discussions should be initiated about the conditions for the
peaceful and secure existence of a state of Palestine side by
side with the state of Israel. If the Israeli government does
not proceed immediately and forthwith to discussions with
the Palestinians over the basic issues of the mutual recog-

nition of the two peoples and the existence of two states, then the Occupation will collapse, not through stones but through the refusal of more and more people to take part in it.

Blindness and folly are liable to lead to a situation where there are no territories and no peace. I believe that even now the number of Israelis who feel like this is far greater than the number of those who are prepared to draw the logical inferences. Every day a few more eyes are opened. But every day more people are killed and every day the hatred and blindness spread further.

In the race between the opening of eyes and the intensification of hatred, which side will win, reason or hatred? These days are as fateful for Israel as 1947, the eve of independence. But the official shortsightedness reminds me more of the autumn of 1973, when Israel failed to sense the impending disaster of the Yom Kippur War.

Weekend Guardian, 23–24 December 1989)
(*Translated by Nicholas de Lange*)

Telling Stories under Siege

LET ME TELL you a story.

Once upon a time, twelve thousand, six hundred and eighty-eight years ago, in a gloomy cave, or by a stream maybe, some rough, simian people with heavy jaws were sitting around their bonfire. It was windy and wistful. Round about these people there lurked the beasts and the ghosts and the goblins.

Besieged by these menacing forces, gnawed from within by fear and savagery and a dim longing for peace, these tribesmen felt a need for something which could soothe their fears, something which would translate the awesome darkness round about them into something else which they would probably call 'sense' if only they had this word. Here enters the tribe's storyteller, who might have been the witch-doctor and the public dream-decoder as well.

His stories might have been every bit as terrifying as the besieging reality out there. In fact, his stories might even have had more terror in them than the wood or the bush in the dark, his monsters more monstrous, his spirits more evil, his ices more frozen, his fires more blazing. Yet in the stories the horror was caught in words and the demons were contained by form.

Fate, death, wild human desires, love and cruelty, as well as the elements themselves, were tamed by the storyteller, who imposed on them the net of language, and of meaning. Meaning in the sense of telling head from tail; of setting a beginning and a middle, an ending, a reason, and maybe

some sort of pattern to boot. 'Meaning' could be rhythm, structure, mockery, some kind of sound-repetition, or even a conclusion.

And so the tribe's storyteller-healer-conjuror might have excited his audience while lulling it into a certain peace; thus helping his fellow tribesmen to withstand the perpetual state of siege. That's what he did, or, better, should have done – because literary criticism in those days was almost as fierce as it is in our day and age – and if the tribesmen did not like the story they could always turn their dinnertime entertainer into the main course for their dinner.

Thus, with only a first-rate storyteller standing a chance of surviving, he must have focused on what really mattered, not on footnotes. He must have made the Elements, the angry ghosts of ancestors, the monsters or the lightning or the flood, death and desire, dance to the music of his words. And words were things, not just representations of things. Hebrew, my own language, still preserves this magical union: the Hebrew word *Davar* signifies a thing, a word, an object and a message, among its various meanings. Just re-read the first few verses of the Bible, of Genesis, and see for yourselves that the Almighty was actually telling himself a story to disperse his own desolation and – much like many other, lesser storytellers – he might have been just carried away, or just expanding a short story into a novel, or maybe simply unable to create a decent ending.

Now, I realize that rather than talk to you about primeval storytellers, rather than evaluate God's literary merits and difficulties, I ought to talk to you about the present: why is it that contemporary storytellers seem to be losing their audiences? Why don't they read our stories, even though the siege is still all over us? (And not just in my own country, but everywhere.) Mighty monsters, vicious goblins, governments, angry ghosts and nuclear warheads are still hovering over us. Despair, death and desire are still at work, along with politicians and pollution and the press. Our fellow tribesmen – fellow tribespersons, if you insist – are

still in need of the comforts of songs and tales and plays, on top of, or despite, or because of, television and the motion pictures.

Still, they seem to be less and less eager to resort to stories nowadays. Or maybe something has gone wrong with us storytellers? Haven't some of us forgotten what it's all about? Haven't some of us simply lost the magic spell?

Sometimes I get the feeling that several contemporary storytellers have grown much too clever; clever as opposed to shameless. Clever as opposed to gutty and elemental. Haven't we been reading recently too many poems about the craft of making poetry? Too many novels about making novels? I mean, books about writers who fail to produce their next book, went to see their analyst over their writer's block, ending up with writing yet another bloodless novel about a novelist who could not produce and dashed to see his analyst.

Shameless storytelling is quite rare nowadays in many countries (not everywhere, though: Latin-America seems to be thriving with gutty tribal conjurors!). But in many other places, the magic of dealing with the Elements in an elemental way is becoming rare; using language – galvanizing language – with elemental power, is rare. The secret spell of purging evil spirits by exorcising them into words seems to have been forgotten in many tribes. What we get instead is brilliant – or not so brilliant – fiction. But the name of the spell is neither brilliance nor fiction – it's shameless storytelling under siege.

I am not here to review 'the state of world literature today'. Instead, I wish to tell you one or two things about storytelling in Israel. We have Modern Hebrew for our musical instrument. Modern Hebrew is a volcano in action, a lasting earthquake, a melting lava (perhaps not unlike Elizabethan English). Some contemporary Israeli storytellers and poets are taking wild liberties with the language, legislating into it new words, new forms, new structures.

Besides, as you all know, my own tribe is caught in a

nasty situation – literally under siege. Hence the urge to tame absurd realities and to force them into patterns of some sort or another. Moreover, very often, recent Hebrew books do hurt, infuriate or antagonize their readers. Those of our writers who act as tribal conjurors are widely read and sometimes widely hated in Israel. Not that they can change the country, but from time to time a poet or a storyteller in Israel succeeds in uttering a healing word; in writing a poem or a story which carries, to use a legalistic cliché, 'a certain redeeming value'.

Not that Hebrew poets and writers have a prophetic status in contemporary Israel (only false prophets enjoy that status in their own lifetime). Our works are often misunderstood and distorted by readers and critics, trivialized into flat political statements. Yet the tribe *is* listening; books are widely read, and books can hurt all right.

And so they really should do, everywhere, not only in Israel, not only where the siege is a literal one. Moreover, in a sense, books ought to be destructive. I would even go so far as to challenge a trendy taboo and point out a 'social function' of literature. At least in one way, there is, in my view, an immediate social function: to remove stereotypes; to destroy clichés, be it that of 'the sleeping beauty' or be it 'the greedy Jew' or 'the bloodthirsty Arab' or 'the Russian Bear' or 'the civilized West' or 'black is beautiful' or 'make love, not war' or 'make war, smash the wicked empires'.

Remove stereotypes. Yet, who created most of the stereotypes which literature ought to remove? Yes, I do plead guilty ... we poets and storytellers have created most of them. And while we shatter those, we are bound to create new ones; which, in their turn, ought to be demolished by another generation of mythbreakers and mythbearers.

Should this game go on and on for ever? Yes, I say, indeed it should and would because this *is* the name of our awkward game.

But this, perhaps, should be the subject of another talk, or of a different story. Ours ought to be concluded soon.

I would conclude it with a simple credo: storytellers, I believe – dealing with society or with history or with landscape or with sex, politics, lunacy or whatever – ought to try to tell their stories as if each is the first story ever told; to tell them shamelessly. Or else, we are bound to sink into clever arabesques of erudition, or allusions of brilliance, trying to beat the scholars at their own game. Storytellers should have the guts – and the innocence – to begin a story with sentences such as 'Once upon a time . . .'; to return to the elemental simplicity of tribal conjurors; to act as hedgehogs and foxes and centaurs. To be wolves and lambs, earth and river, water and wind.

People want very many things. Of course some of the things we want contradict some of the others which we want just as badly. Peace and excitement, for example: just think of all the gushing traffic out there – people going out in all directions searching for excitements, while others go in the opposite way, looking for peace and serenity. A thousand different kinds of peace, of course, and seven thousand varieties of excitement. So it is with all of us, since we were small children, toddlers, waking up on a bright morning, full of zeal and frenzy, wanting to be taken to the zoo to watch the big animals and the funny animals and even the dangerous animals, then suddenly aching to be back in our safe place, beyond the drawn curtains, under the woolly blanket, in peace and cosiness.

Now, here *is* the magic of storytelling: it can give us peace through excitement, it can give us excitement within peace.

For one thing, I believe we all share the experience of sitting alone at home by a cosy fire on a stormy night, reading a good story about the wrath of the Elements and the enigmas of the human soul, thus carried into laughter, yearning, mercy, anger, fear and trembling – all within the utmost peacefulness which is there in every good story, no matter how horrific its plot or subject might be.

But, above all, telling and hearing stories under siege

makes the siege itself slightly more bearable. Whenever a poet or a storyteller touches the Elements with the elemental power of words, we, the readers, experience the unbelievable touch of overwhelming excitement united with utmost peace: like icy fire. Which is, in one of many ways, healing. And which is, I believe, a partial triumph over the evil spirits.

Speech, Writers' Conference, Barcelona, 1976
(*Translated by Maggie Goldberg-Bartura*)

The Israeli-Palestinian Conflict: Tragedy, Comedy and Cognitive Block

A storyteller's point of view

REMEMBER THE LAST SCENE of *Hamlet*? The one where the tragedy suddenly turns into a farce? When everyone seems to be stabbing the wrong person with the wrong sword? Well, the Israelis and the Palestinians are now almost ready to swap the poisoned swords. At the same time, they are almost ready for an uneasy compromise and for a sad and sober peace.

Let us look into the tragic-grotesque option first: the Palestinians, adopting traditional Zionist arguments, insist that they will not rest unless their historical rights are restored. The Israelis, for their part, relinquish the weapon of historical rights to replace it with what used to be a traditional Palestinian argument: 'the natural case of a native'. An Israeli, born in a predominantly Jewish Haifa, possibly born there to parents and grandparents who were also born in a predominantly Jewish Haifa, can hardly be expected to relinquish Haifa to some stranger who has never even been there, but claims that Haifa is where his ancestors came from. In short, 'the right of memory' might once again clash with the 'right of being there', except that the Israelis can resort to a former Palestinian argument and vice-versa. The poisoned swords are swapped, the bloodshed continues – unless we all realize that wherever there is a clash between right and right, a value higher than right ought to prevail, and this value is life itself.

Let us consider the term which all sides have been using abundantly: 'rights' – 'historical rights', 'natural rights', 'legitimate rights', 'ancestral rights'. Israelis and Palestinians have been claiming for at least a hundred years now that they are the rightful owners of the country which we call the Land of Israel and they call Palestine. Even the pragmatists on both sides are sure of the axiomatic validity of their respective rights to the land, but ready perhaps to consider forfeiting part of it for the sake of a peaceful compromise. Let us ponder on this term, 'right to the land', thus adding another drop to the ocean of arguments which have been used, misused, refuted, reformulated or turned upside-down during the course of those 'one hundred years of solitude'.

Perhaps rather than speak of a clash between 'right and right', it is better to speak of 'claim against claim'. The term 'right', at least in its secular sense, stands for something which is recognized by others, not for something that someone feels very strongly about. You may have the deepest conviction that a beloved person, place or object is exclusively your own, but as long as this is not the way others see it what you have is a claim, not a right. If you gain partial support then you have a stronger claim; more support would turn this claim into a disputed right. Further recognition still would turn it into an established right. The line between 'claim' and 'right' can only exist where there is an accepted law, or where there exists a standard system of values. The case of the Land of Israel, or Palestine, as it stands after almost a century of struggle and upheavals is roughly as follows: the whole world recognizes Israel's rightful existence in the Land of Israel, but nobody supports an Israeli claim over the whole Land of Israel. At the same time, although everyone supports the Palestinians' right to self-determination in Palestine, there is only a very marginal support for a Palestinian claim over the whole of Palestine. This situation is a reasonable starting point for a possible compromise. I believe in a two-state solution: an Israeli recognition of the Palestinian right to self-determination, in

return for Palestinian and Arab readiness to meet Israel's legitimate security provisions, to reach a comprehensive agreement, and to renounce all further claims on all sides.

Possibly the worst patch of the Israeli–Arab conflict is now over. And I am not implying by this that we will not be seeing any more bloodshed. Oh yes, I am afraid we will. But the good news is that the cognitive block, which existed, in different ways, on both sides, is beginning to dissolve at last: for too many years, in fact for decades, the Arabs believed that if they were only to rub their eyes hard enough, Israel would go away, like a nightmare; go away like a mobile exhibition, perhaps, that can be transferred elsewhere. Many Israelis, for their part, have believed for too long that the entire Palestinian issue is not a real one. That Palestine is nothing but an invention by a vicious Pan-Arabic propaganda machine, aimed at eroding Israel's integrity and damaging its reputation abroad. Now both sides are beginning to sober up. Both sides are opening their eyes to face reality. And it isn't easy for either of them. This is not the beginning of a love affair. If anything, it's like a patient awakening from an anaesthetic slumber only to discover, with pain and frustration, that, after surgery, things are never going to be the same again. There is a lot of rage and disillusionment, sadness and insecurity on both sides. But I think they both now realize that the other side is real, is not about to go away, and, in fact, that the other side is here to stay. Many people on all sides are now aware of the fact that it's not enough to call Washington DC long-distance and tell them: Will you please get those terrible people off my back! This phase of the conflict is over. Gone are the days when Arabs, by and large, refused even to pronounce that 'dirty' word 'Israel', preferring to resort to self-deceiving expressions, such as 'the Zionist entity'. Gone, too, are the days when Israelis, by and large, preferred to refer to the 'country's Arab inhabitants' or 'locals', in order to evade the term 'Palestinians'. Yes, we have all made considerable progress in the last decade. What Mr

Arafat is now proposing to the Israelis, although too late and too little, would still have been enough to cause the Mr Arafat of the past to shoot today's Mr Arafat in the head. What the Israelis are now proposing to the Palestinians, again too little and too late, is enough to make socialist Golda Meir turn over in her grave.

Despite the suspicion, frustration and rage on both sides, let us not be blind to the fact that the progress we have all made recently is very significant indeed, considering our respective stances of ten, twenty, or fifty years ago. Now the Israeli-Arab conflict is at long last becoming a dispute about real estate, not a theological dispute, nor a racial clash, although some fanatics on both sides are trying to turn it into a holy war. Essentially, it is now a dispute over real estate: whose house? Who is going to get how much? Such conflicts can be resolved through a compromise. And I am not suggesting that the compromise can be reached overnight, or over a few months. The issues are very real and very painful: security, settlements, water, boundaries, a comprehensive Middle-Eastern security system, and so on. Nevertheless, from now on, Israelis and Arabs are no longer talking about who is going to go away altogether, but, rather, about who is going to get what, and how much. Which is what I would call 'normalizing' the conflict. Unlike former Yugoslavia, unlike Northern Ireland, probably unlike Lebanon, the Israeli-Palestinian clash is an international conflict and not a civil war. An international conflict and not a civil rights issue. In one hundred years of tension and violence, these two societies have remained two societies – this making the 'choice somewhat easier'. This observation does not, however, refer to Israel's Palestinian citizens: theirs is not a case of divorce, but of legal equality, democratic plurality and multi-ethnic coexistence within Israel.

Naturally both sides are now apprehensive, both of them have to undergo a major change. But let me, for a moment, be the advocate of the hawks in Israel, although I resent them wholeheartedly. Still, I would like to give them a fair

hearing. The hawks feel that whereas Israel is expected to relinquish real estate, to give land, to forfeit strategic assets, the Palestinians and the Arab nations are only expected to produce a piece of paper, a nice document, which may so easily be torn to shreds the following day. This, say the Israeli hawks, is an uneven deal, bearing in mind the instability of the Middle East, the rise of Islamic fundamentalism and the violent nature of disagreements in the Arab world. But some of the apprehensions of these sincere Israeli hawks (as opposed to fanatic and demagogic hawks) *can* be alleviated, if the contract contains an element of time as well as one of space: the Palestinians *will* gain sovereignty over the West Bank and the Gaza Strip, although they won't do so overnight. It will happen phase by phase – the fulfilment of Palestinian national rights will be deployed over a period of several years, and delivered not mile by mile, but one attribute of sovereignty after another. Israel will have enough time to find out if the Palestinians and the Arab nations are able to deliver peace. If they will be able to contain their extremists and zealots. If an effort is being made to create a new atmosphere. If there are evident syndromes of emotional de-escalation.

You may be sure that the Palestinians, too, are apprehensive. They, too, are having to change some of their dogmas, some of their basic concepts, and, in order to meet this, Israel is going to have to exhibit significant changes in her attitude towards them. First and foremost, perhaps, towards its own Arab citizens.

As both sides are uneasy and worried about the impending progress, now is the time for the 'outside world' to help calm both sides down. It would be a stupid mistake for public-opinion makers to cause the parties even more anxiety and paranoia by calling this or that party names. Let people of good will and well-meaning governments outside the region stop wagging their fingers in disapproval like old-fashioned Victorian schoolmasters. Instead of finger wagging, they might consider some scheme to incorporate

a future peaceful Middle East into an international security system or a European security system or a Mediterranean one. This could help both sides overcome some of their fears. One could conceive of a plan for incorporating a peaceful Middle East into the European economical system or maybe a Mediterranean economical system. One could devise a Marshall Plan for the Middle East to help resettle about one million Palestinian refugees as well as some million Jewish refugees from the former Soviet Union and elsewhere. This would certainly be a worthwhile contribution. And, by the way, don't worry about the cost; I believe that within some fifteen years a peaceful Middle East would be in a position to fully repay the sponsors of such a Marshall plan, or better still to initiate its own Marshall Plan for less privileged parts of the world, for Africa, for example, or for Latin America. Potentially, the Middle East is a very rich region.

I believe the Gulf War has been an extremely sobering lesson for many on all sides. At a painful cost, I think some Palestinians have learned that there is no hope for them in just sitting around expecting some Saladin to come riding up from the East on a white horse, throwing the Jews into the ocean and ridding them of the need to compromise. The Israeli hawks have learned, at a no less painful cost, that the extra forty kilometres, which is what the Occupied Territories are all about, do not necessarily grant the country absolute security in an age of ballistic missiles.

I don't expect the two parties to fall in love with each other. Let's not be sentimental. Even after peace is achieved, both parties would most likely still disagree as to who was to blame for the whole conflict; they would disagree about the past. They would almost certainly remain divided as to who was David and who was Goliath in this conflict. And, by the way, the issue is not an easy one: the question of which is David and which is Goliath depends on framing. If you focus on the West Bank and Gaza, then the Israelis are a clumsy Goliath, and the stone-throwing Palestinians

are poor little David; yet if you change the zoom and put the frame on the conflict between Israel with its five million citizens and over one hundred million Arabs, or worse still, between Israel and many hundreds of millions of Muslims, you'll get a totally different notion as to who is David and who is Goliath. Fortunately, there is no need for the parties to agree on this issue: peace is still possible, even between parties who have different notions of the past.

In order to understand the Israeli psyche, you must bear in mind the Israelis' legitimate fears and apprehensions: for seventy years now Israel has more or less lived out the experience of a collective Salman Rushdie. For seventy years there has been a death sentence hanging over our heads, issued by Islamic fundamentalist leaders and by Arab politicians. It is only understandable that the Israelis have grown untrusting, even neurotic. Such a Salman Rushdie experience would be enough to drive even the sanest society insane and I can hardly claim that Israel is the sanest society. So we really do have good reason to be nervous, frightened and even neurotic about our security. I know that Palestinians have equivalent feelings, having, for decades, heard many Israelis describing the country as it was before the Jews started to settle it as 'an empty land'.

The two conflicting parties, as I have said elsewhere, see threat in each other precisely because they see in each other a facet of their European tormentors from the past. But making peace comes prior to changing hearts: time and again, I receive these invitations from well-meaning European and North American institutions to come and spend a few days in idyllic retirement with Palestinian artists and intellectuals, in order that we all get to know and like one another. It seems that many well-meaning people in the West have completely forgotten that conflicts *do* exist. These people seem to believe only in 'misunderstandings' that may somehow be settled through group therapy, or marriage counselling, in quiet, pleasant surroundings. Well, I've got some news: there are no basic misunderstandings between

107

Israelis and Palestinians; there is a very real conflict: they want the land because they think it belongs to them; we want it because we think it belongs to us. Which provides for sufficient understanding between the parties, and for a tragic clash between them. This conflict can be resolved through compromise, through a partition, but not by simply having a nice cup of coffee with the enemy. Rivers of coffee cannot extinguish the tragedy of two peoples loving the same homeland. I don't need to go somewhere for a tête-à-tête with my Palestinian colleagues in order to get to like them – I like them, and yet they are my enemies, and it is precisely because they are my enemies that I believe I need to make peace with them.

The Israeli peace movement has little in common with a tradition in which peace and love and compassion and brotherhood and reconciliation are synonymous. Actually, they are not synonymous. The opposite of war is not love, the opposite of war is peace. Hence my own attitude toward the Palestinians is: make peace, not love. Anyway, I do not believe in love between nations, which is a very naive concept. As the Beatles lamented, 'there just isn't enough love to go around'. To me, as a peacenik, not a pacifist, the ultimate evil is aggression, rather than war itself. Israel's most pragmatic prime minister, Levi Eshkol, used to say: 'There is one thing which is even worse than using violence, and this is capitulating to violence.'

For some time I have been hearing something like this from Western intellectuals: well, the Palestinians, you must understand, they have suffered a lot, they've been oppressed and humiliated, they *are* a part of the Third World, after all, so it's only natural for them to become a bit violent; what else do you expect? The Jews, on the other hand, they've suffered so much, they've been oppressed and discriminated against, how on earth can they, having experienced all this, behave violently? Now this, I believe, is giving double standards a bad name. It may derive from a certain simplistic Christian sentiment – Jesus bled on the cross and

then became God. Consequently every Jew who bleeds on the cross should become an angel. Well, in real life, some victims of oppression and discrimination and racism indeed become more tolerant, more receptive, more sensitive to the sufferings of others. Whereas other victims of the same horrible experience tend to become more vindictive, more angry and more suspicious. Both these contradicting responses to suffering are equally human. They may not be equally humane, but they are equally human. The Nazi gas chambers showered their victims not with some moral cleansing liquid, but with Zyklon-B. I don't even want to mention the grotesque pro-Third World sentiment, which turns Saddam into a good guy, simply because he is against America, and turns Israel into the bad guy, simply because she is associated with America, and being associated with America is the same as being 'Rosemary's Baby', which, by definition, is diabolical. Saddam Hussein is friends with Libya and China, and Libya and China are friends with Fidel Castro, and Fidel Castro has been married to Che Guevara and Che Guevara is Jesus Christ and Jesus is love and therefore let us all love Saddam. Well, I was one of those Israelis who endorsed the need to get Saddam Hussein out of Kuwait during the Gulf War, by force, if necessary, which was a very uneasy stance for a peacenik to take, and did not make me very popular among some dogmatic Western peaceniks. Kuwait had been a bad guy, I have no doubt in my mind about this. A corrupt regime, an oppressive, feudalistic system, stinking of oil and injustice. But I maintain that even a bad guy does not deserve to be violated, and the violator be allowed to get off scot-free. Had Saddam Hussein been permitted to get away with the *Anschluss* of Kuwait, a very dangerous precedent would have been set for all small nations in the Middle East.

I do not share the sentiment of some well-meaning people who always seem to agree with the Third World's every whim and wish, whether right or wrong, for 'the sake of world peace'.

Nor do I admire the Palestine national movement, which I have always regarded as one of the most extremist and uncompromising national movements of our times. I do not harbour a soft spot for Mr Arafat. I will shake his hand tomorrow, if I thought that this would help bring about peace, but nothing in the world would ever make me endorse him. He is no Ho Chi Min, and I am no Jane Fonda, and even Ho Chi Min is no longer Ho Chi Min, as Jane Fonda is no longer Jane Fonda. And anyway, ours is not a Vietnam-like conflict. One of the reasons I am angry with the PLO and its predecessors in the Palestinian national movement, is the amount of misery and tragedy they have caused, not only to us Israelis, but especially to their own people, by, for decades, taking such an uncompromising stance, by endorsing the Nazis in the 1930s and '40s, and by blatantly aiming, and attempting, to exterminate Israel, a purpose they had openly proclaimed for several decades. They might have blinded themselves to reality by misdiagnosing Zionism, by conceiving of it as a colonial phenomenon, and Zionism is not a colonial phenomenon.

Actually, the early Zionists who came to the Land of Israel at the turn of this century had nothing to colonize there. It's one of the few countries in the Middle East with no resources. In terms of colonial exploitation, the Zionists involved themselves in the worst bargain of all times, as they brought into the country thousands of times more wealth than they could ever hope to get out of it. Wrong diagnosis begets a wrong perception and a wrong treatment. So I think that Palestinian ideologists, as well as some of the world's left, should set about revising their concept of Zionism. It's not a form of colonialism, neither is it a form of racism. It is a national liberation movement, and, like other national liberation movements, it has its own ugly, selfish, narrow-minded and fanatic components. It is equally crucial for many Israelis to revise their view of the collective Palestinian identity and to reach the realization that Palestinian freedom is morally inevitable and unde-

niable, and that, as long as the Palestinians have no freedom, our own freedom is doomed to remain crippled. Regardless of my criticism of Zionism, however, and of the Palestinian national movement, I think it is time to make a peace based on compromise. Neither the Palestinians nor the Israelis are lucky enough to have the privilege of choosing their enemy. And it is your enemy you have to make peace with; not because he is 'nice', not necessarily because you feel you have wronged him, any more than he has wronged you. You make peace with your enemy simply because he *is* your enemy.

Self-determination is not bestowed only upon nice and well-behaved people. It's not a decoration for excellent behaviour or for a wonderful record. Were this the case, half the nations of the world should, I maintain, have long been stripped of their independence – Germany and Austria ought perhaps to have been stripped of their independence. But having a good record is not the name of the game. Survival is the name of the game. Survival for both sides.

I am fully aware of the fact that many well-meaning people in the West, indeed in Israel itself, are somewhat disenchanted and disillusioned with the reality of Israel. Our record on civil rights is not good, though not the worst one in the Middle East. Some of our internal conflicts are painful and sometimes ugly. The disagreements about our identity and where-do-we-go-from-here are sometimes very dramatic, sometimes very melodramatic. Some of Israel's realities could not possibly be as monumental as her initial dreams. Israel was born out of the glorious visions and huge expectations not only of her founding fathers and mothers, but also of millions of other people all over the world. With all due respect to Charles Dickens, I would say that, on Israel's visiting card, 'Great Expectations' is her middle name. Various visions and master plans were conceived of for Israel. But, by definition, some of those initial master plans collided with others, as did some of those early visions. There was no way for all of them to have been

111

fulfilled. Moreover, to some extent, unlike communism, unlike many other political visions, Israel is a dream come true. As such, it is bound to be flawed and imperfect, precisely because it is a dream come true. Let me add, right away, that I think that internal questions, such as the place of religion in the state, the implementation of civil rights, the attitude to minorities, cannot be satisfactorily resolved before resolving the issue of the Israeli-Arab conflict. No nation has ever been very good on civil rights while at war with a deadly enemy. We have to resolve the Israeli-Arab conflict first, and then work on some of our painful internal divisions. Moreover, State and Church – in Israel's case State and Synagogue – and the position of minorities, are issues which took Europe centuries of blood and fire to resolve. Many nations, allegedly civilized nations, including America, have only been able to establish their rules of the game through bloody civil wars, rivers of blood and fire. At least in Israel our perpetual internal civil war is essentially a verbal one. In a clash between Israeli and Israeli, the casualties are verbal, and so are the ammunition and artillery. Rather than shoot at each other, we Israelis are constantly giving each other ulcers and heart attacks by calling each other terrible names. This provides for perpetual sound and fury, but also serves as a safety-valve against internal violence. I guess I am trying to convey the fact that although, at the moment, I dislike many aspects of Israel, I love her none the less.

I think the Israeli–Palestinian conflict, as opposed to the Israeli–Libyan or Israeli–Iraqi conflict, is a tragedy in the exact sense of the word. It is a collision between one very powerful claim and another no less powerful. And it is high time for honest people outside the region to conceive of it as a tragedy and not as some Wild-West show, containing 'good guys' and 'bad guys'. Tragedies can be resolved in one of two ways: there is the Shakespearean resolution and there is the Chekhovian one. At the end of a Shakespearean tragedy, the stage is strewn with dead bodies and maybe

there's some justice hovering high above. A Chekhov tragedy, on the other hand, ends with everybody disillusioned, embittered, heart-broken, disappointed, absolutely shattered, but still alive. And I want a Chekhovian resolution and not a Shakespearean one for the Israeli–Palestinian tragedy.

These, in a nutshell, are my politics.

Perhaps the very first joint project to be created by Palestinians and Israelis, as soon as peace between them is established, should be a monument to our mutual stupidity. After all, in the end, the Palestinians are only going to get a fraction of what they could have had with peace and honour back in 1948, forty-five years ago, five wars ago and some 150,000 dead ago, ours as well as theirs. The Israelis, too, will get less than they could have had, had they been imaginative, generous, or even realistic back in 1967, and since. Only the dead will get nothing except for some wreaths and a flood of high-flown rhetoric. However, it is feasible that, before long, a two-state solution will materialize. Obviously, we all have to remember that there are different sets of clocks at work in the world and in the Middle East. The clock of common sense and pragmatism is only one of many. Fear, despair, zeal for uncompromising justice, are also on stage. Conflicts, whether individual, intercommunal or international do not usually resolve themselves through a miraculous formula which sends rival parties falling into each other's arms like long-lost brothers in a Dostoevsky novel; rather, most conflicts tend gradually to fade away, as a result, simply, of exhaustion on all sides. I think this blessed exhaustion is a syndrome recently observed among several Israelis and Arabs.

Let all of us, primarily us Israelis, realize now that the present Palestinian leadership is the most moderate, and the one most willing to compromise, that the Palestinian people are able to produce today, or tomorrow. At the same time, let us all, although primarily the Palestinians, Syrians, and other Arabs, realize that the present Israeli government

is the most moderate, and the one most willing to compromise, that Israel can produce today, or tomorrow. Let's take it from there. Above all, we mustn't forget that Shakespeare might still take over, and that we must work doubly hard for Chekhov. . . .

Lecture, Ann Arbor, 1992

At the Bridge

THE ISRAELI–ARAB war has been going on now for almost
three generations. It began with sporadic attacks by the
Arabs on the Jews returning to their homeland. Later it
escalated into a vicious circle of belligerence, extending all
the way from Iran to North Africa. Tens of thousands of
Israelis have been killed and maimed; and over one hundred
thousand Arabs. In the beginning it was no more than a
feud between neighbours, involving knives and handguns.
Eventually it deteriorated into a war of tanks and planes
and ballistic missiles. With the Gulf War, just two years ago,
it reached new thresholds, verging on apocalyptic means of
mass destruction, at the same time becoming once again a
battle of knives and stones.

Hate-filled fanatics have always attempted to turn this
conflict into a religious war, a race war, a war between
every Jew and every Arab, as are those wars in Ireland and
Bosnia. But the fact is that the conflict between ourselves
and the Palestinians is not a holy war but essentially a battle
of two peoples, both of whom regard this country as their
one and only homeland: that tragic clash between right and
right.

For decades now, we proposed to the Arabs one compro-
mise after another; including compromises which were much
harder for us than the one which is now being negotiated.
But the enemy rejected any compromise and persistently
demanded that the Jews dismember their state and go away.
This was a blunt, cruel attitude which we and they paid for

115

in rivers of blood and an abyss of suffering. The Israeli victory in the 1967 Six Day War was followed by some euphoric years, during which our governments refused to recognize the very existence of a Palestinian people, expecting the Palestinians to forget their national identity and to surrender to our domination over every inch of the land. This Israeli policy was both immoral and unrealistic. And now we have all reached a crossroads: the two peoples are finally about to come to terms with the simple fact that they *are* two peoples and that, for both of them, the country is their homeland. We and they – along with most of the Arab world – are ready now to consider a partition of the land between its peoples. What partition and under what conditions – this question still involves a complex process of bargaining: who gets what and how much and under what terms, and how to ensure Israel's peace and security after the termination of the Israeli occupation of the West Bank and the Gaza Strip. All this must be clarified around the negotiating table, and calls for wisdom, patience and vision. Clearly, in this compromise, the Palestinians are going to get parts of the land, whereas we get documents and promises, and it is therefore crucial that an element of time is included in the equation, so that Israel has time to go to the bank, to make sure that the Arab peace cheque does not bounce. This means that between the agreement and the actual completion of the Israeli withdrawal, some years will have to elapse. In the meantime we will have to hold on to certain positions which will enable us to cancel the deal in case it turns out that the Palestinians are unwilling or unable to deliver their part of the bargain.

In 1947 the United Nations General Assembly resolved to partition the land between its two peoples, along geographical lines which today no Israeli would accept and no reasonable Palestinian would claim. That resolution provided the legal foundation for the establishment of Israel. Palestine, on the other hand, did not come into being in 1947, among other reasons because regular Arab armies

from neighbouring countries occupied territories designated for a Palestinian state. It might be equally embarrassing for Palestinians and Israelis to recall now that, in 1947, whereas Palestine had not been recognized by any nation, not even by Arab nations, not even by the Palestinians themselves who made no attempt to establish their own sovereignty – Israel, and Israel alone, did recognize the Palestinians: it did so in its very Declaration of Independence, proposing at the same time peace and friendly neighbourliness.

Now, at long last, after decades of rejectionist attitude, after several cycles of bloodshed and rage, the Palestinians will compromise for only a section of what the Israelis were ready to recognize as Palestine, back in 1947.

Israel, for its part, is now going back to what for decades used to be the mainstream Zionist attitude: it is once again willing to make an ethical, realistic compromise based upon the recognition of the Palestinians' right to a homeland. Recognition for recognition, security for security, good neighbourliness for good neighbourliness.

And what if they cheat? And what if they take whatever we give them and demand even more, still exercising violence and terror? Within the present proposed settlement, Israel will still be in a position to close in on Palestine and to undo the deal. If the worst comes to the worst, if it turns out that the Peace is no peace, it will always be militarily easier for Israel to break the backbone of a tiny, demilitarized Palestinian entity than to go on and on breaking the backbones of eight-year-old stone-throwing Palestinian kids. The Israeli doves, more than other Israelis, must assume, once peace comes, a clear-cut hawkish attitude concerning the duty of the future Palestinian regime to live precisely by the letter and the spirit of its own obligations.

The plan which is now being negotiated, Gaza and Jericho first, is a sober and reasonable option: if the Palestinians want to hold on to Gaza and Jericho, eventually assuming power in other parts of the Occupied Territories, they will have to prove to us, to themselves and to the whole world,

that they have indeed abandoned the ways of violence and terror, that they are capable of suppressing their own fanatics, that they are renouncing the destructive Palestinian Charter and withdrawing from what they used to call 'the right of return'. They will also have to show that they are willing to tolerate in their midst a minority of Israelis who may choose to live where there will be no Israeli government. Israel, for its part, will have genuinely to deliver the initial Zionist promise: to become a source of blessing to its neighbours; to help herself and them in breaking the vicious circle of suffering, despair and poverty, and to embark upon the road to prosperity.

Arafat and Rabin, Peres and Faisal Husseini will be hearing in the near future from some of their compatriots the word 'traitors' – may they wear this title as a decoration for their vision and courage. Churchill, de Gaulle, Ben-Gurion and Sadat also belonged to this honourable 'club of traitors'.

For many years, thinkers of the doveish left in Israel preached an Israeli/Palestinian compromise, roughly similar to the present one. Initially, they only evoked hatred and loathing from all sides. Celebrating our belated triumph, we Israeli doves must bear in mind how painful these days are for the believers in a 'greater Israel'. Even in the present storm of heated controversy, we must remember that the Israeli opponents are not just the warmongers. Most of them are Israelis who are genuinely afraid that the sky is about to fall in on them, and that their homes and their country are in mortal danger. We have to treat their feelings with understanding and respect, as long as these feelings are manifested in lawful ways. It is crucial that we make every effort to ensure that peace is not built upon anyone's loss and humiliation. It is crucial that we struggle for the right of those Israelis who would prefer to go on living faithfully, in peace and safety, in the regions under future Palestinian administration. We may even hope that, in the future, these Israelis will become a bridge of good neighbourliness – and

will become so with the same enthusiasm and devotion with which they have tried so far to serve as a bridgehead for extended frontiers.

The labour of peacemaking is no matter of emotional outbursts. There is no chance of simply jumping from a seventy-year-old blood feud into a friendship. The labour of peacemaking calls for vision and calculation, for wisdom and generosity and caution, for remembering the malignant past without becoming its slaves. For so many years, we Israelis have told ourselves, sometimes rightly, sometimes as a result of a spasm of fear and suspicion, that we have no partner to talk to, that there is no point in playing chess with ourselves; that we shouldn't place the cart before the horse, that we'll cross the bridge when we come to it.

Well then: we have come to the bridge.

To be more precise, we have reached the point where we and they must begin building the bridge.

Had Israel stuck to the slogan of a 'greater Israel', had Israel continued oppressing and humiliating the Palestinians, trying to turn them into submissive slaves within our expanded borders, their radicalization would have increased to a point where they – and other Arab nations – might have become united under the green flag of despair, waved by ecstatic fundamentalist Islam. Had the Palestinians continued to insist on getting everything or nothing they might have brought upon themselves, upon us, upon the entire region, the horror of a doomsday destruction.

And now, in the shadow of these dangers, it looks as if we and they are about to achieve a viable compromise.

From a Zionist perspective, it may be that in the future people may regard the year 1993 as the end of our one hundred years of solitude in the Land of Israel. This may be the end of the prologue for Zionism, and now, perhaps, it's time to begin the Israeli story proper, to consolidate Israel as a safe, stable, legitimate home for the Jewish people and its Arab citizens; a focus of creative energies; a source

of blessing for Israel's neighbours – including the Palestinian neighbours.

There are no sweet compromises. Every compromise entails renouncing certain dreams and longings, limiting some appetites, giving up the fulfilment of certain aspirations, but only a fanatic finds compromise more bitter than death. This is why uncompromising fanaticism always and everywhere exudes the stench of death. Whereas compromise is in the essence of life itself.

The Torah says: 'Thou shalt opt for life.'

Let *us* opt for life.

Guardian, 1 September 1993
(*Translated by Ora Cummings*)

Hizbollah in a Skullcap

EARLY ON FRIDAY morning (25 February 1994) a Jewish settler from Hebron entered the Cave of the Patriarchs and murdered dozens of Arabs while they were at prayer.

The murderer, a well-known supporter of Rabbi Meir Kahane, was supplied with ammunition by Israel, which has armed dozens of other Kahane supporters. After the massacre, a curfew was placed on Hebron. As the region's military commander explained, Kiryat Arba, Hebron's Jewish suburb, was not under curfew, 'because no such instructions had been received'. Only towards evening did the government remember to impose the curfew. This did not prevent some Jewish settlers from appearing on television, extolling the slaughter with such monstrous sanctimony as would not have shamed a skinhead.

On 17 September 1948, Count Folke Bernadotte was murdered in Jerusalem by members of an unknown, armed Jewish group, which called itself the 'National Front'. Although this crime was considerably less grave than Friday's murders, David Ben-Gurion did not hesitate for a moment: within two days the Provisional Government of Israel published regulations calling for heavy punishment, not only for active terrorists, but for all members of terrorist organizations. The Lehi and the National Front were outlawed. In the very midst of those difficult days of war, David Ben-Gurion diverted large numbers of troops to the task of crushing Jewish terror. Some 200 people were arrested

121

immediately. Widespread searches were carried out in various parts of the country. The leaders of Lehi were arrested and made to stand trial.

The government of Israel should immediately outlaw all of Kahane's supporters, see to it that known inciters are placed under arrest and brought to trial, instigate house searches in Kiryat Arba and other possible terrorist strongholds, and suggest that, as a result of the massacre, it will consider incorporating armed Palestinian police in the peacekeeping forces guarding trouble spots outside of the Gaza and Jericho regions.

I have no idea if the murderer received assistance from anyone, although we have long been familiar with the inciters – these are the same inciters who, unlike Islamic fundamentalist agitators, were not deported, nor will they be deported over the border and their homes will not be destroyed or sealed up. But I see no difference between this Jewish murderer and these Jewish inciters and the Hamas and Islamic Jihad murderers and inciters: they do all in their power to prevent the Israel/Arab war from being resolved through compromise; they do all they can to turn it into a religious war between Judaism and Islam, between Adonai and Allah – till the very last drop of blood has been shed.

This murderer and the inciters behind him did exactly what the Hamas and the Islamic Jihad hoped. Hamas murderers and inciters do exactly what the zealots on the Jewish side expect. It is as if when darkness falls, a mirror image of the Oslo Congress convenes, where the sides have no difficulty in agreeing to drown the peace accords in blood and revenge.

Dozens of families in Hebron will no longer see their father, their brother, or their son. Little children will have to be told that those murdered were murdered in revenge for the murder of others murdered, who were also murdered in revenge for murder which was a revenge for a murder. Or they might be told that it happened in order to ensure

that peace will never come, since peace is worse than death. That is unless people of both these nations stand up and choose life and set about immediately realizing this determined decision of theirs.

Various reactions have been heard over Israeli radio. The Prime Minister, politicians, including leaders of the country's right, expressed all kinds of outrage and fury at the murder. Aharon Domb, spokesman for the settlers, while not praising the 'grave action', was able to understand the motives for it. Chief Rabbi Yisrael Lau, too, renounced the 'shedding of blood', but evaded using the word 'murder' – perhaps because the murdered were not Jews. Among the shocked reactions, I counted five or six observant Jews, all of whom condemned the 'event', some even used harsh words, but none of them found it necessary to call the murder 'murder'.

It is difficult, therefore, to avoid asking the following question, a question that is neither an Israeli-Palestinian one, nor a doveish-hawkish one, but a question of morals between Jews and other Jews. As far back as the trials of the Jewish underground members, some of whom were convicted of murder, there were many observant Jews who asked for a pardon for 'those good lads who had taken the law into their own hands'. Why, in fact, were the Chief Rabbi and other observant Jews content to use the expression 'bloodshed', this time too, instead of calling the murder a 'murder' and the murderer a 'murderer'? What, then, is the proper name for the Purim massacre in Hebron? Pour your wrath on the Gentiles? A reckless act by a beloved son? An incident? Is the commandment 'Thou shalt not murder' relevant only when the victim was born of a Jewish mother or was converted to Judaism by an Orthodox rabbi?

The answers will determine neither the future of our region nor the future of the peace and the territories. Nor will it determine the meaning of the word 'murder', or who is a 'murderer'.

At most, it may have the power to determine once and for all who is a Jew. And who is none other than Hizbollah in a skullcap.

Observer, 27 February 1994
(*Translated by Ora Cummings*)

Clearing the Minefields
of the Heart

'THE PALESTINIAN'S DEMAND for self-determination is a legitimate one. One can postpone its realization for reasons of the threat to Israel's existence, but one cannot deny its justice in principle.

'Where right clashes with right the issue can be decided either by force or by some imperfect compromise which neither of the parties would regard as just. Such a compromise can be achieved only between an inconsistent Palestinian and an inconsistent Zionist. Justice, absolute and all-encompassing, is, of course, on the side of those who argue that there is no difference in principle between Ramle in Israel and Ramallah on the West Bank, between Gaza and Beersheba ... this is precisely what extremist Palestinians and extremist Israelis claim ... each claims it all for himself.

'Between individuals as well as between nations, it sometimes happens that a fragile co-existence can be made possible only by virtue of inconsistency. The heroes of tragedy, driven by consistency, consumed by righteousness, destroy each other. He who seeks total, supreme justice, actually seeks death.'

I first wrote those lines twenty-six years ago, shortly after the rightful and tragic Israeli victory in the 1967 Six Day War. They may still be a fair summation of the attitudes of the Israeli Peace Movement. Tonight, as our movement rallies here in Tel Aviv, it looks as if this attitude is finally beginning to prevail over the Israeli-Palestinian conflict. Yet

let us bear in mind that this is far from being the end of the road. At most, it is the end of the prologue.

Our moderate, pragmatic principles are now being adopted by the Israeli government and by the leadership of the PLO, but all around us, reality is still soaked with hatred and suspicion. This is no time for celebrations, but a time for even greater effort and responsibility. Hard as it is to change the policies of leaders, it is harder still to change the hearts and minds of people in whom hatred and fear have gathered over many decades. Yet, as of today, this, precisely, is what we are going to have to do: no longer prophets of doom, no longer a protest movement, we must now become the sappers, whose job it is to clear away the minefields in the aftermath of war.

However, the work of diffusing the emotional minefields between Israelis and Palestinians can be successful only if a Palestinian Peace Now movement emerges, parallel to ours, and gets to work on neutralizing the explosive rage and bitterness within their own people.

Their streets and ours are filled with the ugly voices of uncompromising fanatics. Amongst the Palestinians as amongst ourselves, hysterical voices are screaming out against 'treason'. From both sides we hear dark threats to stifle this new peace before it has even had a chance to stand on its own feet. Let us warn the Israeli inciters who call for the destruction of this embryonic peace by taking the law into their own hands that we are going to defend it with the same determination with which in the past we have not hesitated to defend our own lives on the battlefields. The opposite of peace is not, as they say, 'a love of the Land of Israel'; it is a continuation of death and destruction. Let us remember that it was Palestinian demagogues and inciters who brought upon their people decades of suffering, deprivation and exile. Israeli demagogues and inciters have always tried to stifle any compromise agreement between ourselves and the Arabs. That's what they did on the eve of the Peace Agreement with Egypt and that is what they

did in 1947/8, when Israel was established on the basis of our initial consent to the partition of the land between ourselves and the Palestinians. Fortunately, at almost every moment of truth, our fanatics lost, and the concept of fair and realistic compromise prevailed. This time, too, it will prevail.

However, we must not forget that here in Israel we are confronted with the resistance not only of demagogues and inciters. There are a great many good Israelis who feel that this agreement is almost the end of the world for them. Many people in this country genuinely believe that this agreement is no more than a wily ruse, no more than granting the enemy a bridgehead to our destruction, no more than the risky gamble of our future security. It is not our business to defeat these Israelis or to ridicule their apprehensions. Actually, we ourselves share some of their fears and doubts. It is our role now to do everything that is humanly possible in order to persuade them that we are not intoxicated by 'Peace at all costs', that the present agreement is a cautious and calculated one, taking into consideration our national security problems even in the event that the Palestinian partner does not deliver peace, and that the risk we are taking is a limited one compared with the potential horror with which we will be faced if we miss this opening for a settlement. The Peace Movement must now avoid all sorts of empty protests, it should refrain from pressing the government for even more concessions each time the negotiations run into some difficulty. Let us bear in mind that, as of today, we are no longer a movement of protest; we must bear full responsibility now that the nation is at long last embarking upon the road that we have recommended for so long. The Peace Movement should focus on its new task of conducting an intensive public dialogue with those Israelis reluctant to accept the new reality. There is no chance of bringing about a reconciliation between ourselves and the Palestinians unless we succeed in generating at the same time a process of emotional de-escalation amongst

127

the people of Israel. This is the time to prove that the Israeli Peace Movement wants to become and is capable of becoming also a movement for domestic peace within Israel. Although not at the cost of relinquishing our own principles and visions. But, perhaps, at the cost of giving up our urge to square up with the right for everything we have had to swallow from them for so many years.

Both hatred and love stand between Israelis and Palestinians. The hatred is the result of many years of unrelenting fighting – fighting which came as result of the love which binds them and us to the same homeland. Nothing in the world can undo the love which both nations harbour for their mutual homeland. Both peoples have already proved this love, through sacrifice as well as through memory and adherence. This may be the dawning of a new era in which our love and their love for the country may cease to be a cause of mutual hatred.

Two stubborn peoples, two peoples well-versed in suffering and persecution, two peoples who have shown through generations of struggling with each other that they are capable of both determination and devotion – now both of them finally stand a chance at turning those virtues into building their 'semi-detached house'.

Even a long and bitter conflict can sometimes create a deep and secret kind of intimacy between enemies. This intimacy may from now on be used for reconstruction and rehabilitation. There is, of course, a long way to go yet, a way full of fury and disappointments, but one can see at last the first hesitant lights of hope. Those lights are flickering right now on this beautiful evening in many windows in Ramallah and Natanya, in Jenine and in Afula, in villages and refugee camps, new lights, still blinking in surprise, like the eyes of someone who has stepped suddenly out of a very long darkness. Let us and let the Palestinians give strength to these lights, let us cherish them and defend them.

For we shall not for ever live by the sword. And death shall have no more dominion.

Speech, Peace Now rally, Tel Aviv, 4 September 1993

(Translated by Ora Cummings)